WILD DUCK - (Anas boschas)

THORBURN'S LANDSCAPE

THORBURN'S LANDSCAPE
The Major Natural History Paintings

———◆———

JOHN SOUTHERN

BOOK CLUB ASSOCIATES

LONDON

First published 1981 by Guild Publishing,
the Original Publications Department of Book Club Associates

© as to text: John Southern 1981
© as to illustrations: The Tryon Gallery Ltd 1981
except Plate XXXVI, George Rainbird Ltd

Designed by Graham Keen

Set in Monophoto Bembo
and printed and bound in Great Britain by
W. S. Cowell Ltd, Ipswich

CONTENTS

———◆———

List of the Plates

ARCHIBALD THORBURN: AN APPRECIATION

For he painted the things that matter,
The tints that we all pass by,
Like the little blue wreaths of incense
That the wild thyme breathes to the sky;
Or the first white bud of the hawthorn,
And the light in a blackbird's eye;

ALFRED NOYES

Archibald Thorburn was born at Lasswade near Edinburgh on 31 May 1860. He was the fifth son of the miniaturist to Queen Victoria, Robert Thorburn, whose artistic talents had first been spotted when, as a small boy, he drew in chalks on the pavements of his native Dumfries. He was born in 1818 and after an early spell at the Dumfries Academy moved south to London in 1836 where he remained for almost a quarter of a century. Even as a comparatively young man he was recognised as the foremost miniaturist of his time, quickly gaining favour with Queen Victoria who commissioned him on three occasions to paint her portrait, and whose portrait of Prince Albert was a particular favourite with Her Majesty—one that she invariably kept upon her table. In 1848 he was elected an Associate of the Royal Academy returning to Scotland in 1856, where he died in 1885.

From a very early age Archibald Thorburn was intrigued by all forms of wildlife and by the time he was six or seven years old was already often to be found drawing and sketching twigs, leaves, and flowers from the garden at Viewfield House. It quickly became apparent that he had been fortunate enough to inherit his father's artistic skills, and by the age of twelve he was producing some beautiful little watercolour drawings and pen and ink studies that already showed exceptional talent and great promise of things to come. Initially he was his father's pupil and although he did spend a period at art school, much later in his life he wrote gratefully of his father's infinite care and patience in those early, formative years, and particularly his insistence in understanding and mastering the anatomy of all the creatures he was drawing and painting. Whilst his father was seemingly quite ruthless in demanding his son to do even better at every stage of this early training, regularly tearing up studies with which the young Archibald had been well pleased, Thorburn always considered that he learned more from his father than from anyone else and was eternally thankful for his strict discipline in those early days.

Some of his very earliest studies were of flowers and other botanical specimens, an interest and love he retained throughout his life. Indeed very many of his bird illustrations as well as his complete and huge compositions contain floral pieces, delicate and charming in themselves and always beautifully executed.

By the time he was twenty and after his short spell at art school, he had made such rapid and competent progress that he not only entered, but even more significantly had accepted, his first work for the Royal Academy in the Summer Exhibition of 1880. For the next twenty years he regularly exhibited large and striking compositions until finally a combination of the pressure of private commissions and book illustrative work, coupled with his obvious disappointment that his pictures had often been hung too high in recent exhibitions for them to be properly seen and appreciated, forced him to forego these enormous and compelling works for the Academy and the year 1900 saw his last majestic entry entitled *The Eagle's Stronghold*.

His talent during this very early stage of his career was not passing unnoticed and his first published illustrations of birds appeared in 1882 in J. E. Harting's *Sketches of Bird Life*, one of a kestrel (Thorburn later complaining that it showed the influence of a golden eagle on which he had recently been working) and one of a group of blue tits. A year later W. Swaysland's book *Familiar Wild Birds* was published in four volumes containing Thorburn's first published colour plates, 144 in all. During the next few years he produced a variety of other illustrations but it was not until January 1887 that he began his long and highly successful association with Lord Lilford of Northampton, who had recently embarked upon a standard work on British ornithology, *Coloured Figures of the Birds of the British Islands*. Lord Lilford had commissioned the well-known artist J. G. Keulemans to illustrate this mammoth work but he fell ill and for a while it was feared no worthy successor would be found. However, the publication of Thorburn's colour plates for Swaysland had been noted, and when approached by Lord Lilford he at once agreed to endeavour to undertake this huge task which he himself acknowledged was the opportunity of his lifetime. He ultimately completed 268 of the 421 plates that appeared in the book.

His first plates appeared in the September 1888 issue and were such an immediate success that demand for the subscribed book, issued in parts, increased threefold. Never before had such beautiful plates of birds been seen either at home or abroad, combining as they did unparalleled scientific accuracy with the fresh softness of the living bird. For the first time in ornithological illustration, science and true art had been drawn together. No longer did the subjects resemble the dead skins from which they had been drawn, lifeless and motionless diagrams, unbalanced and often grotesque in posture and proportion. The plates were a revelation of how scientific accuracy and art could combine and all previous coloured ornithological plates fell immediately into commonplace beside Thorburn's. His reputation was at once assured and his place in natural history art established beyond question. The acclaim afforded Thorburn on the publication of these beautiful plates was in no way ill-conceived or of only a temporary

nature, for now almost a full century later they are still reproduced in several bird identification books, being the most widely reproduced bird pictures of all time, thus confirming their true and timeless value, as well as perpetuating the artist's skills for the benefit and pleasure of present and future generations.

This monumental and highly successful effort completed, taking all of ten years, Thorburn busied himself with numerous private commissions together with a variety of illustrative work in collaboration with several leading natural history personalities of the day. Such names as Augustus Grimble, McPherson of the acclaimed *Fur Feather and Fin* series, and William Beebe come to mind and particularly that of fellow artist naturalist J. G. Millais, with whom he worked closely in the production of several fine and successful books, primarily during the period 1902–13.

It was not until 1915–16, however, that Thorburn finally produced a book on British birds entirely on his own, coping with the text as well as the illustrations. This too was an instant success. *British Birds* was in four volumes with a large paper edition of 105 copies selling out before publication, and more than 1,000 copies of the ordinary edition being marketed during 1916. In all some 2,550 copies of the book were sold. Advertised by Longmans in their prospectus at 6 guineas for the set in 1915–16, a clean copy today would cost £500 or more. The original plates for the book were later sold in aid of the Red Cross. Other lavishly illustrated books followed in relatively quick succession, all enjoying great acclaim and a ready sale. In 1926 his publishers, Longmans, with whom he enjoyed a long and happy association, suggested that he should produce a book on butterflies and flowers and it can only be our loss that this was never done, for although they had published a fine set of prints on a similar theme several years earlier, Thorburn declined on the grounds that he considered such a book would have a much more limited public appeal than the bird and mammal books, with a correspondingly disappointing rate of success. One cannot help wondering if this was not perhaps one unfortunate decision by an otherwise extremely wise and shrewd man, for surely no book containing his beautiful and delicate renderings of the butterflies and the flowers of these islands, always a love of his since childhood, painted at the height of his career, could have possibly been anything other than an instant success.

Following his education at Dalkeith and Edinburgh, Thorburn moved south to London soon after his father's death in 1885, living first at 25 Stanley Gardens and then at 88 Fellows Road, only a few minutes stroll from the home and studio on Primrose Hill of Joseph Wolf R.I. Wolf was a German who had made his home in this country and Thorburn admired him greatly, considering him the best draughtsman of wildlife the world had ever seen. Wolf proved to be of considerable help to the young Thorburn, offering much advice and encouragement before he died in 1899.

In 1896 at the age of thirty-six, Thorburn married Constance Mudie, whose father had founded the famous Mudie Lending Library, and they had one son, Philip. Two years later in 1898 Thorburn was elected a Fellow of the Zoological Society and was for many years a member of the Royal Society for the Protection of Birds, being made vice-president in 1927 in recognition of his services on behalf of bird preservation. He painted their first Christmas card in 1899 showing roseate terns accompanied by a verse by the Poet Laureate, Alfred Austin, and over the next thirty-five years produced eighteen more, all of which he gave to the Society for them to sell in their effort to raise much needed funds. Indeed, the last picture he painted was for their 1935 card, showing Britain's smallest and most delicate bird the goldcrest, a commission with which he struggled whilst lying in bed suffering his last, painful illness.

In 1902 Thorburn and his wife went to live in the lovely secluded village of Hascombe, nestling undisturbed in the Surrey countryside, close to Godalming and within easy reach of London and the gallery of his dealer, A. Baird-Carter of 70 Jermyn Street. (On his death he was succeeded by his partner W. F. Embleton in 1919, with whom Thorburn dealt for the remainder of his life.) Here, in this idyllic retreat undisturbed by the rumble of the outside world, and surrounded by the birds and beasts he knew and loved so well going about their daily lives in their habitat of fir and larch, beech

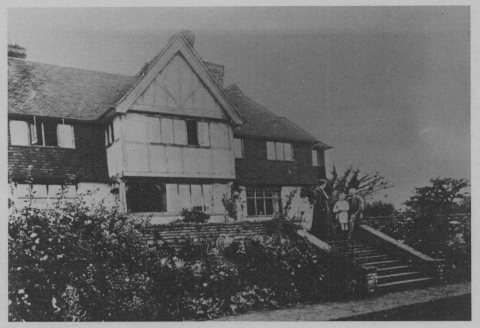

Thorburn with his wife and son at Hascombe

and oak, he remained and worked for the rest of his life.

He lived quietly and undramatically. In fact his wife Constance once likened his life to 'a smooth deep river flowing for ever serenely on'. Each morning he would take his cold bath followed by his daily helping of porridge, made from the finest Scottish oats which he had specially sent down from his fatherland by the hundredweight. Regularly he would take his customary stroll through Hascombe woods and on into Juniper Valley—a mere ten minutes or so from his own home, armed with fieldglass and sketch-book, sometimes calling at the village shop on his way home for lunch where he could be gently persuaded to show

what interesting creatures he had seen and drawn that day. He was a very reserved and shy person, quite unassuming and singularly modest when faced with praise, gentle and charming and invariably helpful and kind. A distinguished looking country gentleman with his meticulously groomed white hair and beard, who spoke softly in a Scottish accent to the village school on how to draw birds and animals, illustrating his talk with incredibly talented and deft chalk sketches on the blackboard.

Each year he returned to Scotland to replenish his sketch-books with studies of blackcock, capercaillie, ptarmigan, eagle, and red deer, to meet again old friends and to visit old haunts, particularly his beloved Forest of Gaick in Inverness-shire where practically all his studies of ptarmigan and red deer were made, and where he had seen his first wild red deer in September 1889. The output of such trips is recorded in numerous sketch-books where one observes his painstaking and at times persistent efforts to record faithfully all that he saw. Many of these studies would eventually find their way into huge and compelling major works of bird and beast struggling to survive in their wild and bleak landscape. In his early years he carried and used a gun on his visits to the Scottish deer forests, until one day he was greatly distressed at wounding a hare and, hearing its cry, never shot again.

Thorburn passionately loved his garden at High Leybourne, Hascombe, a small fifteen-acre estate that he had purchased and built on just after the turn of the century, with its flowers and shrubs which he had planted set against a background of fir and larch. As mentioned earlier, flowers were an abiding love of his from his earliest memories at Lasswade right up until his final days at Hascombe in 1935. Invariably some spray of blossom or glorious bloom will appear in his pictures of birds and animals, even his identification plates, thus adding another dimension to the scene as well as incorporating reality by their inclusion.

Throughout his life Thorburn retained his shrewd Scottish sense of business, caring little for the dealers who, until they learnt better, tried to do him down on more than one occasion in their early associations. He was quietly firm yet extremely fair and often most generous in all his dealings though invariably economical in his approach. On one occasion, when a visitor was admiring the magnificent rockery Thorburn had recently constructed in his garden, he remarked that he had been out there for more than a week and, jerking his head towards his studio window, added 'I often wonder what it cost me'. Recalling another incident, he was showing a visitor a huge study of apple blossom perhaps 40″ × 30″ and when asked whether he had cut off the branch and taken it into the studio he replied 'Oh no, just think of the apples I would have lost'. But, whilst often thrifty in his approach to his own affairs he was generous and kind to those less fortunate than himself. A stockbroker client who fell on hard times and

reluctantly had to sell his treasured watercolours wrote to Thorburn and, explaining the position, added that the pictures had made a profit. Thorburn replied that he was glad he had made a profit though sorry for the reason. Some months later a large picture of red grouse was delivered to the stockbroker's home with a short note that read 'At least you shall have one'.

Archibald Thorburn was unquestionably one of the founders of modern bird painting, being probably the first wildlife artist to go out into the field and make innumerable sketches from life. His predecessors, and indeed some of his contemporaries and followers, relied almost entirely upon museum skins in their work not only for plumage detail but also for pose and attitude, often with most unfortunate results, particularly if the specimens they were drawing had been poorly or incorrectly mounted. However, since his earliest days, Thorburn had chosen to make pencil sketches of all items of interest and this habit developed and flourished as he matured. All of his finished pictures were, in fact, the result of initial observations and sketches taken from life, combining a selection of poses from perhaps half a dozen or more study sheets of, for example, grouse drawn on different occasions with a background composed from suitable rock, heather, and hill, studies possibly originally sketched on completely different occasions. Thus he would put a major work together, not hesitating to use a certain amount of licence when referring to his original sketches, yet ending up with a fine picture of grouse composed entirely from original working sketches from life.

Thorburn painted almost entirely in watercolour, relying quite heavily on Chinese white to give body and form to sections of his work, sometimes using tempera and occasionally painting complete pictures in gouache and in oils. Of the latter he completed very few, usually complaining that he found them considerably more difficult to execute and disappointing in their result, the medium not, in his opinion, being the equal of watercolour with which to represent the softness of a bird's plumage. He also painted minutely on ivory and confidently on plaster murals. Significantly, the only two miniatures on ivory he ever did were of his favourite birds, woodcock and blackcock. Between the ages of twenty and forty he painted in a relatively tight, restrained fashion devoting considerable attention to detail, almost labouring some tedious group of birch branches or monotonous reeds in a foreground which one observes were quite painstakingly done. As time passed he gained in confidence, freeing up progressively, using more water on his brush, no longer labouring a particular aspect of the picture, until in his sixties he emerged as the complete master of his medium, flowing on the magnificent backgrounds of hill or forest, farm or fen with breathtaking ease and confidence, enriching the work with exquisitely painted landscape hints surrounding the delicately drawn birds or beasts that form the subject of the picture.

Thorburn usually sat at an easel whilst painting in his studio at Hascombe, which was light and airy and equipped with a washbasin, a lavatory, and an ingenious escape door to the garden readily used should he hear unwelcome voices at the door! Often, whilst painting, he would jump up and, rushing to the window, make a quick pencil sketch of a goldfinch or other bird that had just flown into view. He primarily worked on continuous cartridge A paper, preferring it to be somewhat mellowed with age in order better to absorb the paint and allow him greater flexibility in creating effect in his inimitable style. He also used a great deal of a much cheaper tinted paper, which considerably speeded up the finishing and highlighting of bird or beast compared to working it up on a pure white surface. He used only Windsor and Newton paints and sable brushes and did all his own mounting of the finished pictures. He was extremely industrious and rested only on a Sunday. Always nervous of electricity, he relied entirely on oil lamps and would never work by artificial light. As a consequence, on summer days he would start early and finish late but in winter his output was considerably curtailed by the brief hours of daylight.

Once he had decided upon the overall composition of the picture he was about to paint, perhaps a pack of ptarmigan near the top of a corrie at Gaick Forest, his method was to draw in his subjects firmly usually with the minimum of pencil work, referring to the relevant sketch-books, and then quickly begin to paint, bringing on all the picture together, background and birds, finally stressing by deft highlighting and bold shadow the main figure or figures. He worked with great dexterity and sense of purpose, seemingly having clearly visualised the whole completed composition in his mind before beginning, and rarely hesitating at any stage of the production of the work. He was a great colourist, revelling in laying on the gay colours of the countryside. He excelled at generalising and in fact his subtle skill at hinting at bracken, fir, or larch without actually painting them frond by frond is one of his supreme accomplishments. His renderings of sprays of blackthorn or hawthorn were particularly beautiful and successful, as were his impressions of delicate swaying birches scattered over the heathery hollows in which the blackcock hide.

Thorburn's place in natural history art was established by the time he was thirty in 1890, when it was agreed that he was the best ever to come from Britain. Now, almost a hundred years later, he remains unrivalled and his reputation has grown considerably internationally, indeed, it is difficult not to place him the foremost artist of his particular subject. Quite unlike his predecessors with their misdrawn and often grotesque birds, his contemporaries who faithfully copied the mistakes of the taxidermist and his followers who, inspired by faded stuffed birds and an occasional visit to the zoo, relentlessly paint harsh, photographic, lifeless

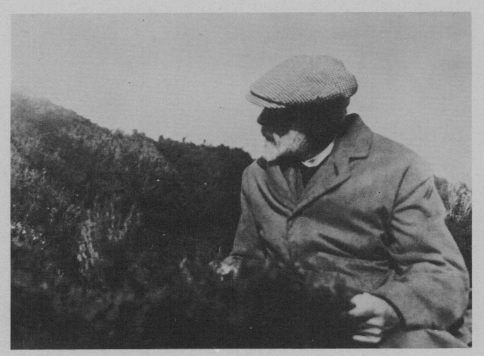
Thorburn sketching in the Highlands in 1927

maps of birds' plumages, Thorburn gave us birds which look alive. With his faultless technique and expert field knowledge, he was equally at home working on a covey of red grouse on four foot paper as he was with a bullfinch on a spray of blackthorn on paper measuring 7″ × 10″, there seems to have been nothing too large nor small for his observation and sympathy. The balance of his birds was impeccable and the eyes and feet of his subjects always expertly handled, two areas that trouble many of his followers and most of his predecessors. His pictures contained a strange freshness, delicate and sympathetic in their execution, timeless in their appeal and whether painting his two favourite birds the blackcock and the woodcock or the bird he always considered the most difficult, the robin, they are characteristically alive and full of vitality.

He was a complete master of light and shade relying upon it almost entirely to give form and shape to his subjects and incorporating it expertly in his backgrounds, the most lovely ever painted in natural history pictures, deftly hinting at Nature in all her varied moods. Whether it be the lush abundance of a woodland at midsummer, or the unclad landscape sprinkled with the snows of winter revealing the innermost secrets of the woodland that midsummer hid, each of his complete pictures is so beautifully and delicately lifelike, utterly compelling and so compassionately painted, that one is at once spiritually transported back to some best loved scene from one's past.

Slowly yet surely, Thorburn is climbing the ranks to take his rightful place amongst the leading English watercolourists. It is not all that long ago that he was considered nothing more than a painter of birds who perhaps knew more about them and where they lived than other artists in that field. Now, however, it is appreciated and agreed that from his painstaking observations and studies from life, together with his highly personal, gifted touch, he knew how to make them vibrantly alive, and when set in his competent and beautifully constructed backgrounds, with their skilful generalising and masterly use of light and shade his

work already ranks highly in the field of English water-colour art, and his major paintings are now priced accordingly in the sale rooms.

Thorburn died at home at Hascombe on 9 October 1935 after a long and painful illness borne with the utmost patience and cheerfulness. His nurse of those last few weeks recalls how cheerfully he greeted her on her arrival at his home on 13 September 1935, even though he was confined to bed and terminally ill. She wrote in her diary 'he is so well endowed with old world courtesy and still has a delightful twinkle in his eye.' After his death she wrote 'A truly wonderful gentle gentleman; I feel very privileged to have nursed him and shall treasure the picture he gave me all my life.' Following his burial at Busbridge churchyard, without fuss, ceremony, or even flowers, his lifelong friend, also born in 1860, wildlife artist George Lodge wrote of him: 'Thorburn was the greatest ornithological artist superior to all contemporaries in the same field, with a wonderful gift for placing his bird subjects in harmonious surroundings. Whether he was painting a large picture of a whole covey or flock of birds or merely a scientific depiction of a single bird for a book illustration, his method and execution were equally admirable. His birds were never flat maps of plumage, but were essentially solid, with the correct amount of light and shade and reflected lights and colours, always extremely well drawn. He was an excellent landscape painter, and painted flowers just as well as birds. His

sketches of plant life, foliage, spray of blossom and such like were extremely clever and beautiful. He appeared to visualise a subject so well before beginning to paint it that his work was very rapid, and wonderfully fluent and direct. His technique was dexterous and bold and his colour brilliant and always harmonious whilst his treatment of the plumage of birds themselves was most remarkable. Thorburn was a man of most lovable qualities, very modest about his own work, but never reticent about his own methods of producing it, and always ready to impart his knowledge to others in a most generous way.'

Archibald Thorburn will long be remembered as the artist who gave us the most living pictures of all of our precious countryside and the varied creatures that live and die within its bounds. He succeeded where others have faltered because he unsparingly gave his entire life to a minutely detailed and orderly study of our wildlife and its ways, relentlessly prising the deepest secrets from Nature herself in all her changeable moods. Totally and enthusiastically committed to his task, he had personally tramped the deer forests where the stags roared out their presence, and many times toiled to the high tops to be with the ptarmigan at their wintry sunrise or sundown, forever fascinated by the reflected lights upon the snowy wastes and snow-white birds. Often he had waited, chilled to the bone, for the blackgame to return to the haven of the birches where, with numbed fingers, he sketched them packing ahead of the setting sun. And he

had shared in all the secrets of the pheasants and the woodcock that dwelt close by in the seclusion of Hascombe woods, regularly encountering them on his accustomed strolls through the leafy glades of Juniper Valley.

With this unique and enormous wealth of field knowledge dutifully recorded in a veritable library of sketch-books, combined with his enviable gift of the seeing eye and steady hand, he was able to document faithfully such transient living scenes, contributing his own unmistakable and quite inimitable generalisations of the landscape, aptly hinting at the withering frond of bracken and the uncoiling fern of spring, the curling leaves upon the autumn woodland floor and the chill inhospitable landscapes of winter. Thorburn marvelled at all of these things throughout his life never ceasing to delve further into the limitless intricacies of Nature's patterns and peculiarities and urgently strove to do his utmost to chronicle diligently all he had seen with paint on paper. How indebted we are for his untiring industry and devotion and for his abundant and glorious harvest, for it is now very much a part of our heritage.

Since Thorburn's time a host of wildlife artists have come and gone, employing new and sometimes bizarre techniques with which to try and attract our attention. Many enjoyed a fleeting modicum of fame, some climbing higher and lingering longer on the pinnacle of success than others, before tumbling into the abyss of faded glory and ultimate obscurity. Whilst some remain popular and in demand for perhaps a decade or more, commanding a more persistent accolade, time alone will fix them in their rightful place and fifty years from now how many names, I wonder, will still be upon our lips.

Thorburn, however, survives unscathed from the past with an overall truth, a living freshness, and an obvious compassion for his subject so far unrivalled. His timeless tales of the countryside, impeccably drawn and flawlessly told with brush and paint, yet unburdened with detail, contain something very special and compelling in their message for us and resolutely withstand the onslaught and deluge of modern wildlife art. Their unique truth and vitality built on ceaseless observation and a bold and daring use of colour and shadow, flavoured with their inevitable message emerging from Nature herself interpreted by a technically brilliant craftsman, sets them apart and ensures their everlasting life, charm, and appeal.

If there should be a sound of song
Among the leaves when I am dead,
God grant I still may hear it sped.

JOHN DRINKWATER

16

The Plates

Tenants of the Lake
Watercolour $19\frac{3}{4}'' \times 28''$ 1881

Keeping a watchful eye on newcomers at the lake, the old drake mallard voices his greeting as the little flock drops down to skim and land upon the evening waters. Other birds, becalmed offshore, preen and flap their wings before bedding down amongst the lakeside reeds. The old drake and his party have already staked their claim for the night within a sandy creek and whilst some still feed and preen, others have already been overtaken by slumber.

Thorburn painted this interesting work when only twenty-one years old and whilst some sections of it are understandably immature—such as the reeds in the bottom left-hand corner—the picture does contain some accomplished passages of painting, such as the twist and shape of the preening drake and the lovely head of his female companion.

The breeding season over, mallard, Britain's most common duck, will often congregate into groups or quite large flocks in which they spend the autumn and winter together, being joined by many others from more northern shores who travel south as the icy grip of winter closes down their feeding grounds.

PLATE I

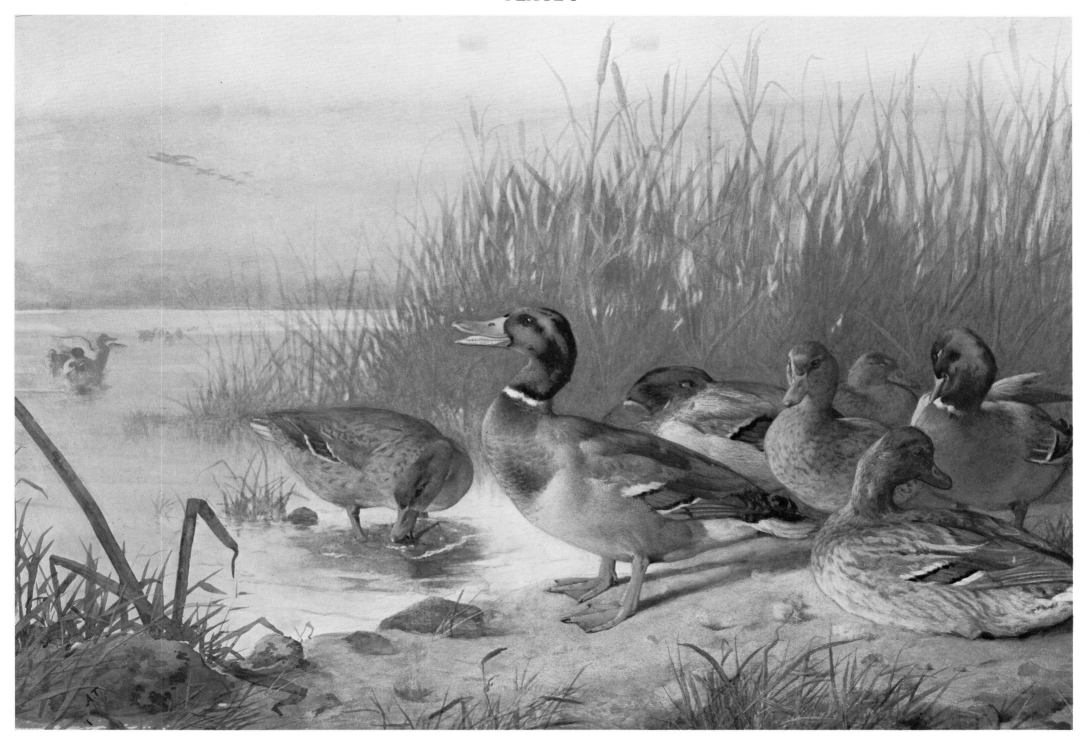

The Gathering Storm
Watercolour 19″ × 30″ 1894

Leaden skies charged with faraway rolls of thunder, ominously resembling the fire of distant guns, bring tension and an uneasy stirring to the pack of red grouse which has been feeding peacefully amongst the autumn heather. Birds swoop in and crouch ahead of the disquiet, as the old cock bird in the foreground sounds the alarm. What had been a tranquil hillside scene a short while ago has quickly become a noisy retreat in front of the impending storm.

Few artists attempt to paint the backs of birds with the subject looking directly away from the beholder, and fewer still achieve any degree of success in such an attempt. Thorburn, however, excelled at this form of

portraiture and the hen bird on the right of this particular picture is a joy to behold, exquisitely painted, being round and solid and convincingly three-dimensional, as though awaiting plucking out of the picture.

Although an early work, painted at the age of thirty-four, this picture contains some beautiful passages of unrestrained watercolour technique, as one sees, for example, in the confident and mature handling of the vegetation midway down the right-hand side of the work, where perhaps even one more stalk of grass would have toppled the balance of the composition. For, unlike building a brick wall, where it is apparent to all that one more brick will complete the task, there is just no way of knowing when a painting is finally complete; and one of Thorburn's greatest merits is that he knew just when to wash his brushes out and say enough is enough.

The red grouse is endemic to Britain, not being found anywhere else in the world. Widely distributed over the heathery hills and moorlands, its distinctive 'Go-bak, go-bak –bak-bak-bak' call is a familiar sound.

PLATE II

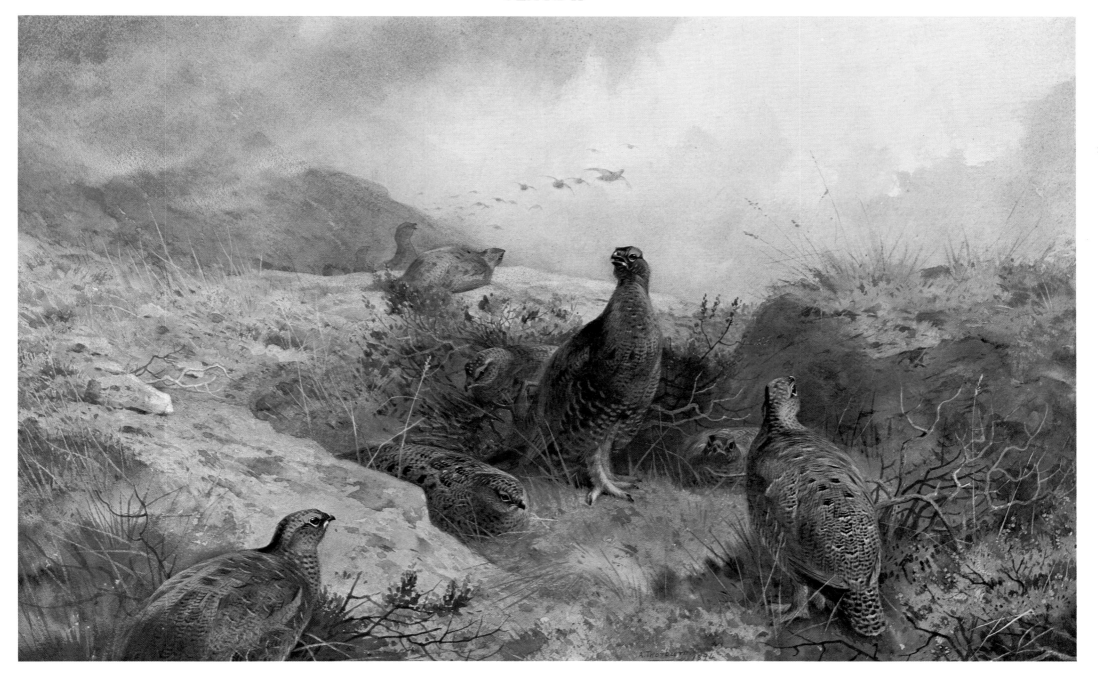

Hard Times
Watercolour $14\frac{1}{2}'' \times 20''$ 1892

Patiently awaiting the thaw, a covey of partridge sits out the hard times in the shelter of a wintry hollow. Cheerless but not defeated by the abounding desolation that winter lays upon the landscape, the birds resolutely await easier times. A weary hare lopes by, pausing to eye the sanctuary of the hollow, keen to secure such a retreat for himself before the brief day ends.

Although painted at the age of thirty-two, Thorburn's concern and compassion for such creatures in such conditions is already apparent. The silent slumbering countryside awaits better times; the birds, the beast, the farmer, and the withered thistle.

As the grip of winter eases, partridge begin pairing in February, though egg laying often doesn't take place until April or May. The nest, well hidden beneath a hedgerow or in similar seclusion, will house the ten to twenty olive brown eggs which the hen bird covers with leaves or grasses when she goes off to feed. The young all hatch within an hour or so of each other and are able to walk and run and leave the nest within a further hour or two.

PLATE III

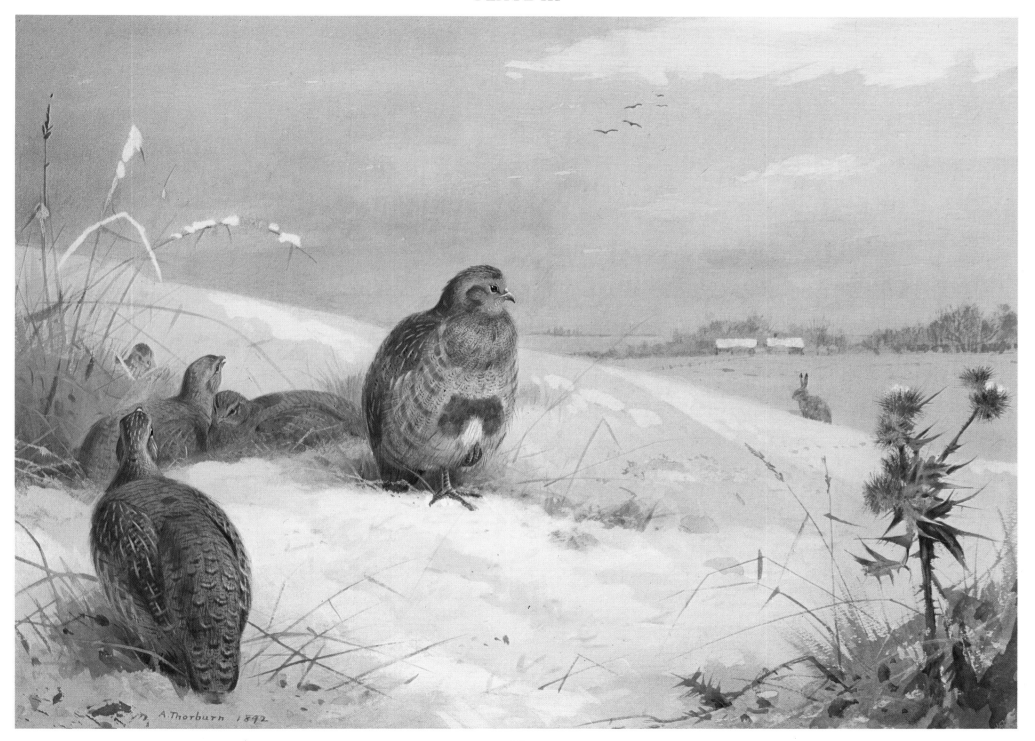

A. Thorburn 1892

Lost in the Glen
Watercolour 28″ × 46″ 1897

Slumped across an ice-cold boulder, a mortally-wounded red deer stag collapses and dies a wintry death, high up amongst the swirling mists on a desolate Scottish hillside. A misplaced shot leaves the beast to succumb to an agonising end, unwittingly stumbling across ridge and ledge until finally he falters, crumpled and limp, across the granite slab.

In that eerie solitude, the lifeless stag lies, silent, emitting only a taint upon the wind. As the brief day draws hurriedly to a close, the still foodless golden eagle chances upon his windfall. The great bird sails in and lands heavily upon the cooling carcase. Almost at once his mate arrives, but, not keen to relinquish or even share the prize, he postures threateningly, anxious to relieve his hunger before the bitter night closes in.

This painting shows all of Thorburn's skills at telling a story with brush and paint. Finding the corpse, he made numerous sketches of the beast and the rock on which it lay and produced other finished pictures from the incident by simply placing the eagles differently. He captures so well the bitter, freezing night that is coming, adding drama to an already compelling scene; and the technician in him shows to perfection in the portrayal of the lifeless eye, now glazed over (not easily achieved in watercolour), contrasting vividly with the living eye of the eagle. His technique for coping with hair is most effective as is the painting of the hooves. And his abiding interest in, and attention to, shadow cleverly springs the back leg away from the rock face. Finally the bullet mark (strategically placed) provides the title —shot, but obviously wounded and lost in the glen, and left to die in agony. So, although at first glance the eagles may seem cruel, the real message of the painting tells us that man can be the most cruel beast of all.

Golden eagles, whilst often found feeding on a dead stag, may occasionally take a red deer calf or young lamb in spring, but their diet largely consists of red grouse, ptarmigan, and mountain hare.

PLATE IV

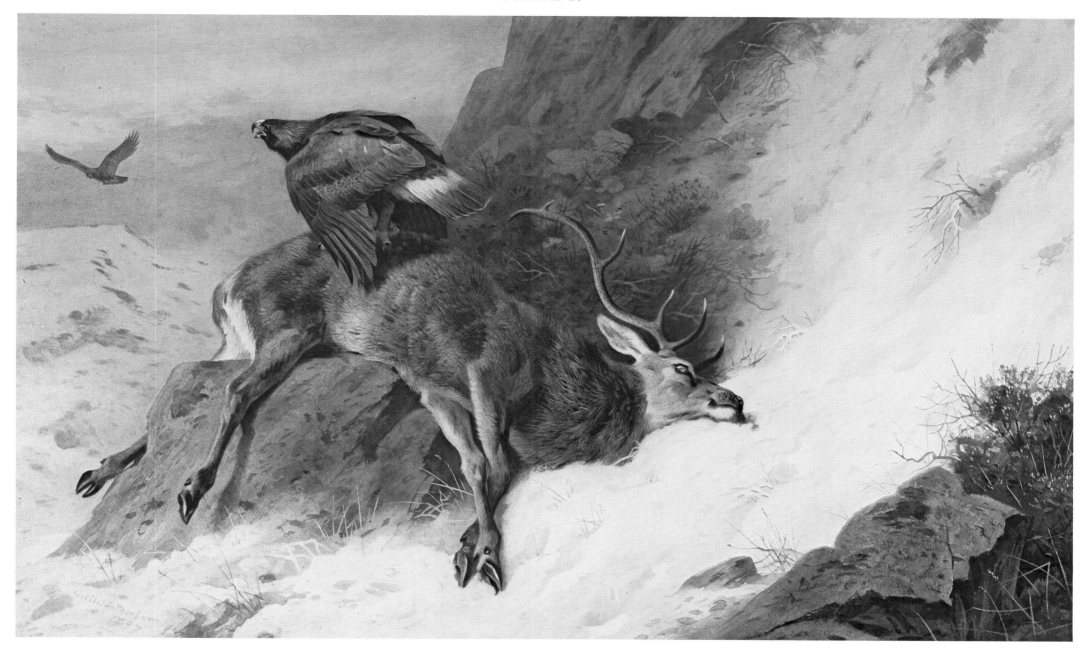

Beating the Coverts
Oil 25½″ × 41″ 1889

The staccato cracking of brittle twigs and sticks mingled with human calls herald the unwelcome approach of beaters in the covert. To the group of pheasants quietly feeding amid the slender trees and upon the autumn woodland floor, such sounds bring alarm and consternation. Always preferring to run for cover, most do just that, scattering in all directions, passing swiftly beneath the bank and on into the depths of their retreat. But others, caught too close for comfort, rise dramatically and with much clattering, almost perpendicularly from the confine of the trees and, much to the satisfaction of the beaters, fly on out of the wood headlong into a line of guns, patiently waiting around the verge of the covert.

One of Thorburn's very few oil paintings. Painted whilst very young it contains passages of exquisite painting, such as the roots overhanging the sandy bank and the realistic woodland interior in the background. Thorburn found the medium difficult to manage and much preferred watercolour with which to capture nature and all her varying moods, and the soft vulnerable creatures that live within her compass.

Experienced keepers are well able to move pheasants steadily out of the woodland to give the waiting guns well-driven and preferably high birds.

PLATE V

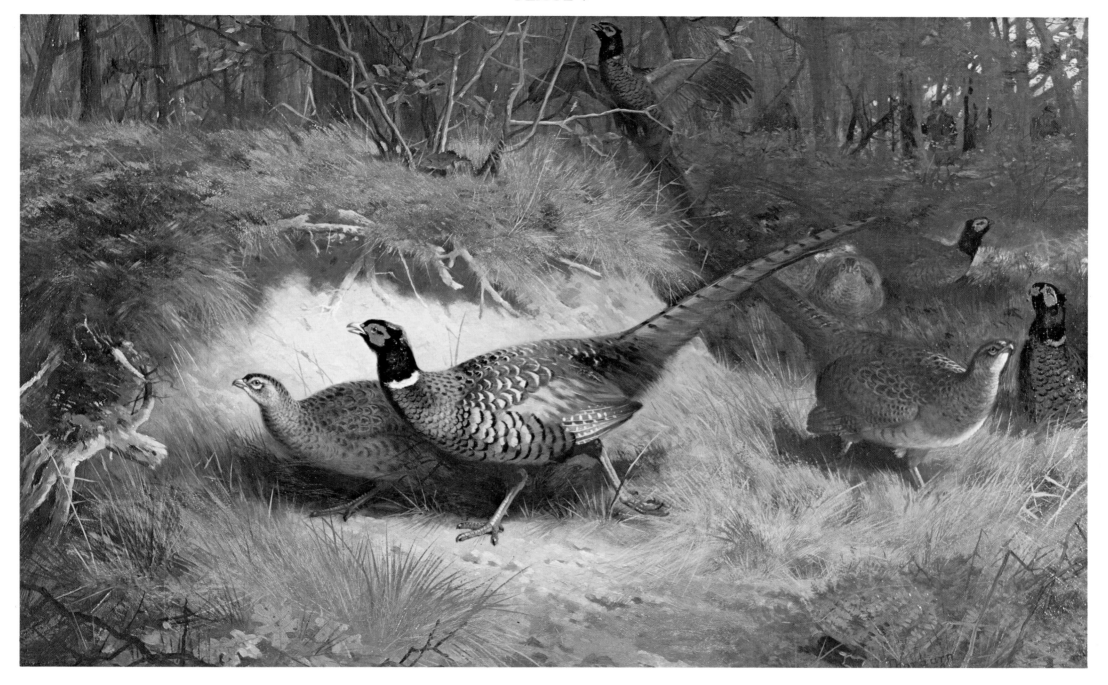

The Monarch of the Glen
Watercolour 28″ × 46″ 1898

Roaring his presence across his wild domain, a Royal red deer stag warns other males to keep their distance and not cast their eyes upon his harem of hinds. Through the break in the clouds his message echoes away to the distant hills. The sudden bellow compels the hinds to raise their heads and listen, perhaps expecting a far-off yet resonant reply to emerge from the mist-strewn landscape, and two red grouse feeding nearby are rudely interrupted by the din.

With tongue in cheek, Thorburn recalls Landseer's well-known work in his title for this huge watercolour. The dramatic cloud effect adds great distance and dimension to the work, and allows the hinds to drift in between it and the distant hills as they cross the burn and pass on into the mists on the other side, thus creating a window in the scene beyond which a further vista appears. Well drawn, firmly standing upon the rock, the stag is nicely formed and given life by means of shadow and such touches as the downward-looking eye and the rubbed-away colour which creates his breath upon the air. Strong shadows behind the hinds, expertly placed, lifts them clear of the contoured back-cloth.

The antlers of red deer stags vary greatly. Normally in their first year the antlers end in a single pair of spikes but when fully grown in about their sixth year the stag will often carry a head of twelve points, when he is known as a Royal.

PLATE VI

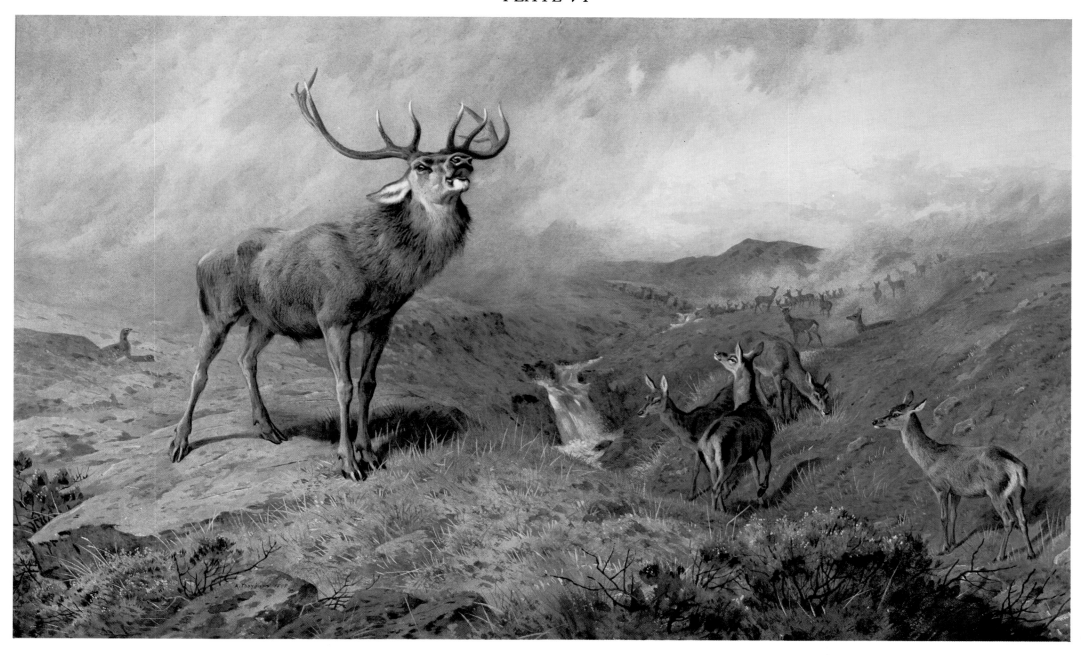

The Covey at Daybreak
Watercolour 27½″ × 45½″ 1892

Greeting the first streak of dawn, the call of the old cock partridge rasps out across the still-slumbering valley below. As the first shafts of morning light touch upon the hillside covey, neighbouring birds drift in to join them from the adjoining slopes. Their chill night upon the stubble over, the covey stirs, and whilst some doze on late, others preen and begin to feed amongst the fallen grain and dew-dropped blackberries. Another day has begun.

Painted at the age of thirty-two and a particular favourite of Thorburn, this work apparently spent some forty years in his studio. Although offered for sale upon completion in 1892, it surprisingly failed to find a buyer and, as time passed, Thorburn became more and more fond of it and decided not to part with it during his lifetime. It is a marvellously sympathetic rendering of these lovely gentle birds which Thorburn so admired, as well as being technically brilliant. The cock bird's head is cleverly placed in the band of brightening sky and the painting of the backs of the birds on the left of the picture is quite exceptional. He cleverly highlights a modicum of grain heads and broken stalks and the early morning light shining through some of the blackberry leaves is very convincing. Finally, the handling of the three drops of dew upon the blackberry leaves is ample evidence of his craft in the use of watercolour.

Partridge are essentially ground-loving birds, preferring to run rather than fly when disturbed. Coveys tend to stick very much to their own tract of land, favouring cornfields or wasteland overrun with weeds as well as the turnip and beet fields of East Anglia and elsewhere which offer valuable cover. The covey, very often a family, stays together throughout the autumn and winter, but around February it disbands as pair formation takes place and territories are staked out for the forthcoming breeding season.

PLATE VII

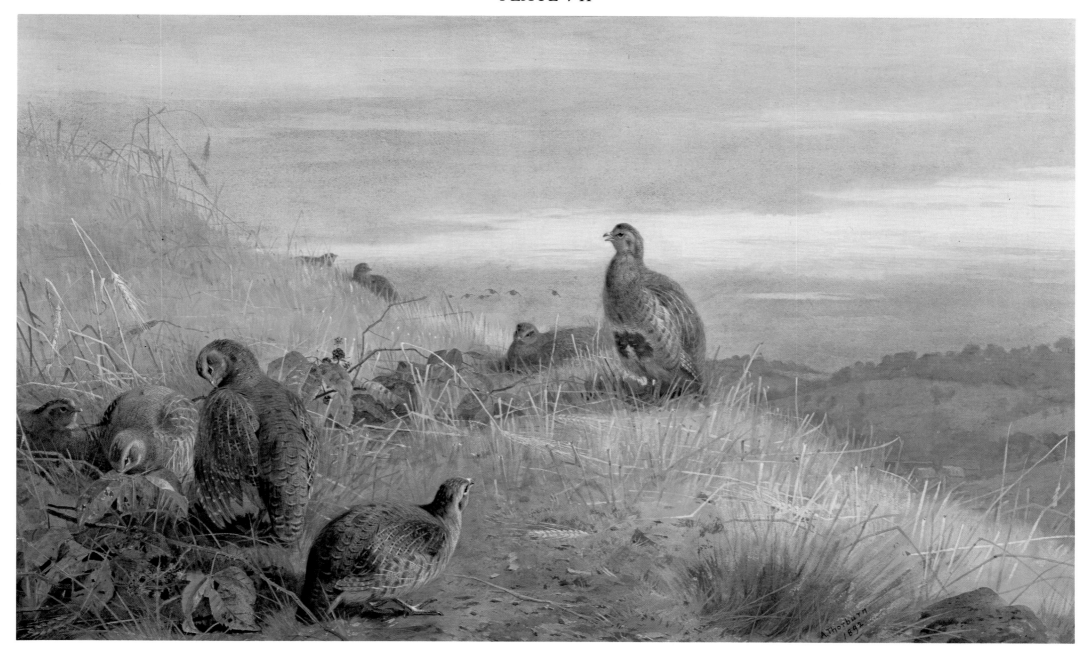

In the Bleak Midwinter
Watercolour 16″ × 30½″ 1899

Two small coveys of partridge stoically endure a continuing cold spell. The surrounding countryside has lain buried deep beneath the snow for some time and the birds have been kept from their normal feeding grounds. Winter's mantle brings a bleak desolation to the scene, banishing the farmer and his stock to the warmth and comfort of the homestead. As chill twilight edges in on the day, the birds take cold comfort from the prospect of yet another long winter's night out in the open and begin to huddle together for consolation and protection.

A wonderfully atmospheric painting, capturing the bleakness of the occasion by the subtle and skilful tinting of sky and snow. Thorburn's enduring sympathy with his beloved birds and beasts shows clearly in his soft, benign rendering of the hungry, patient partridges.

This delightful little gamebird was a particular favourite of Thorburn's and he painted a great many pictures of them during his lifetime. He greatly admired their hardy resilience in the face of adversity and depicted them on numerous occasions sitting out the cheerless times of winter.

PLATE VIII

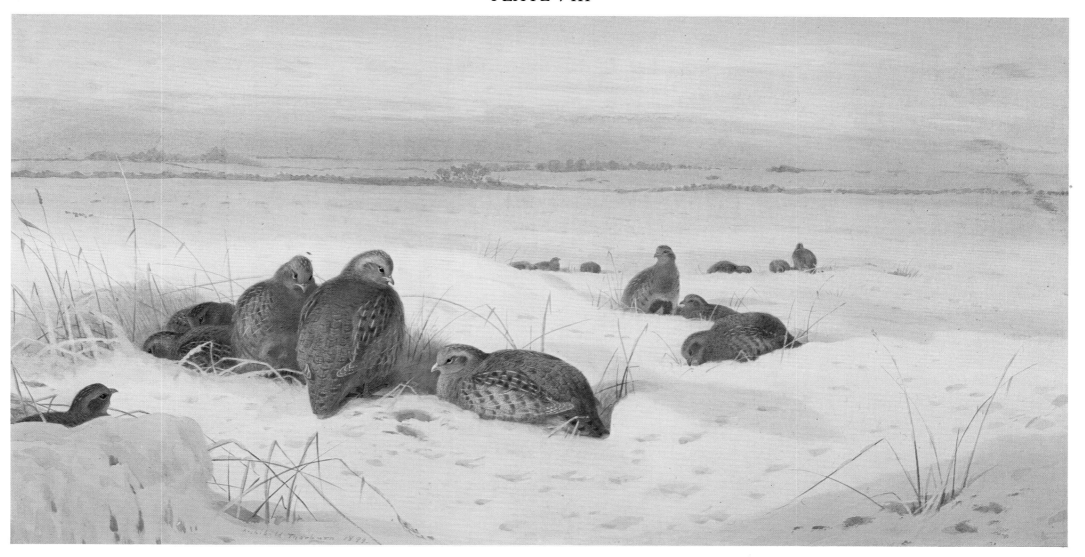

On the Stooks

Watercolour $21\frac{1}{4}'' \times 29\frac{1}{2}''$ 1902

Late autumn is a time of plenty for blackgame. With the moors rich in berries they scarcely need the harvest of the valleys. However, at daybreak and dusk, unable to withstand the sight and scent of the golden sheaves, the birds often leave the moorland loneliness and the seclusion of the birches, and glide in swiftly over old stone walls to raid the arable land. Here they quietly gorge and plunder man's harvest, revelling amongst the malty grains. Then, having taken their fill, they return just as quickly whence they came, to their bivouac amongst the birches.

The superbly painted blackcock, with bright eye and strong feet, represents Thorburn at his best. The delicacy of the distant hills and birch-clad moors contrasts well with the bold execution of the main birds. Light and shade are of utmost importance in their shaping and the difficult demarcation between the dark head of the blackcock and the dark side of the greyhen is well achieved. A scattering of the ears of grain is beautifully picked out and highlighted from the generalisation of the background and the artist's abiding fidelity to nature shows in the single oat stalk across the blackcock's tail and the lone feather about to drift away. Very much a master's touch.

It used to be a common sight in Scotland in autumn to see a pack of blackgame, sometimes a hundred strong, feeding on the oat stubble, but the overall decline in their numbers coupled with the progress in agriculture, means that such scenes are unfortunately rapidly becoming a thing of the past. Enjoying their feed from the stooks and stubble of the crofter's fields, the birds would sometimes consume so much that they became intoxicated by the fermenting grain and could scarcely take wing if alarmed.

PLATE IX

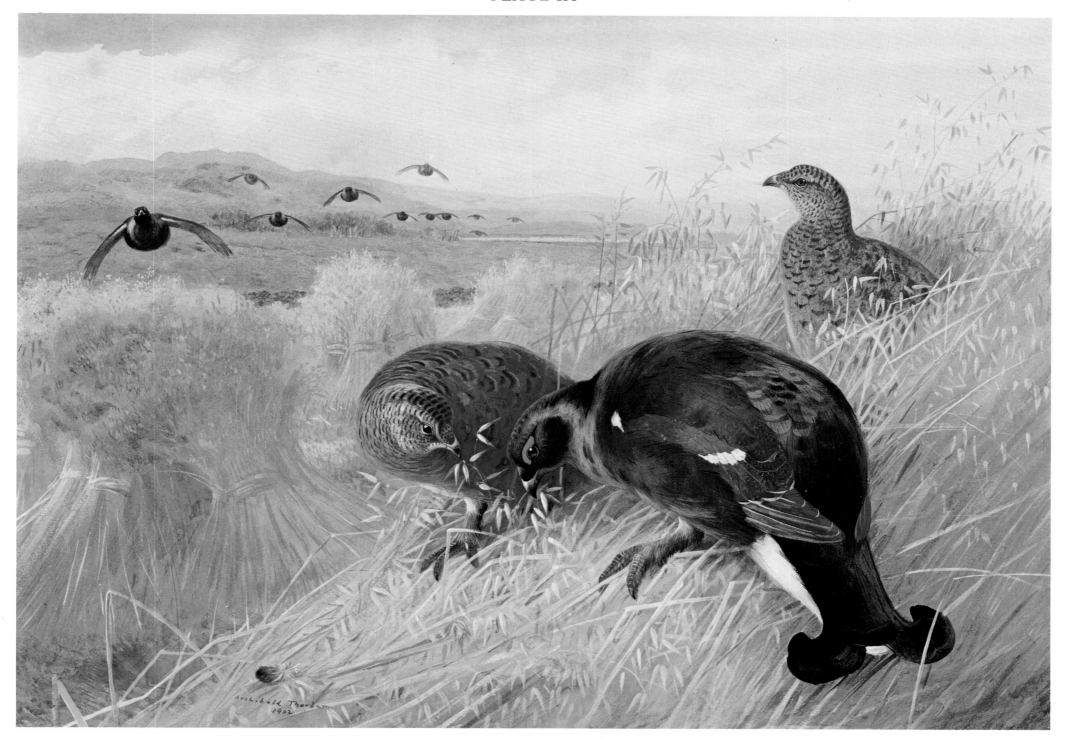

The Lost Stag
Watercolour 30″ × 46″ 1899

Sailing effortlessly over a host of high hill-tops and gliding along vertical cliff faces and through misty glens, the golden eagle chances upon his bounty. A misplaced shot has brought pain and a lingering death to the red deer stag. Wounded but not killed outright in the chase, he fled wildly, losing the sportsmen in the mists and finally succumbing to the fatal injury. Having circled the scene to take stock of the situation, the eagle at last swings in and lands upon a nearby boulder, posturing aggressively lest any other predator should have intentions upon his prize.

Painted at the age of thirty-nine, this huge work represents Thorburn's penultimate Royal Academy entry, his last one appearing in 1900. He exhibited there regularly between 1880 and 1900. His bold use of colour, from the sky above to the grass below, ensures that the work is compelling if tragic, and his expertise with shadow under the legs and hooves of the fallen beast and around the head and the back of the bird—particularly noticeable in his treatment of the shadow on one of its eyes—fills the page with form and shape.

Though nesting in England and in Snowdonia in Wales about 200 years ago and in Ireland in the early part of this century, the golden eagle is now a bird of the Highlands of Scotland. It appears only occasionally elsewhere, although it is now beginning to nest more widely in Ireland.

PLATE X

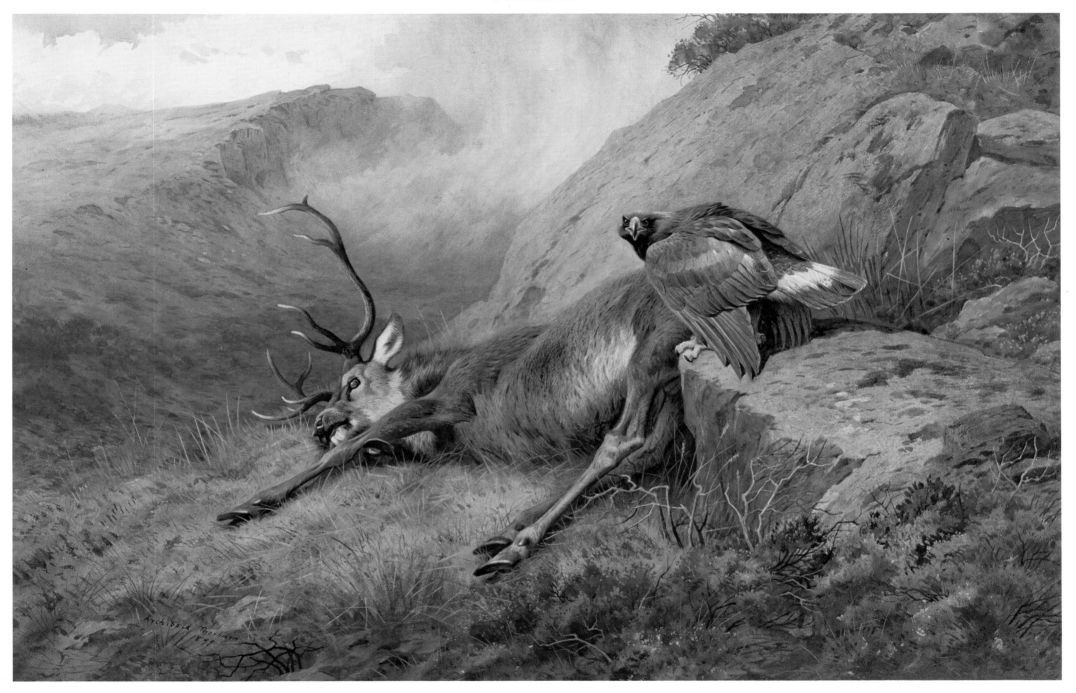

Ptarmigan
Oil $11\frac{3}{4}'' \times 19\frac{1}{2}''$ 1903

Hurtling in over the frost-gripped crags, a covey of ptarmigan pitches amongst snow-white companions already packing upon the comfortless wastes as the sun retreats before the advancing night. Scraping out hollows in the soft snow, the birds seek the meagre shelter of such high places in which to endure yet another chill darkness.

A further example of Thorburn as an oil painter; whilst he cleverly conveys the setting sun's tints upon the snows and the cold blues of the shadowed cliffs, perhaps here we catch a glimpse of the difficulty of which he spoke in capturing the vibrating softness of the living birds' plumage in this medium as compared with watercolour.

Ptarmigan have three changes of plumage during the year: the first, from April till July is the breeding dress

of brown-flecked upper parts; from August until October after the autumn moult they become much greyer; until finally in winter the birds moult again into the overall snowy-white plumage which Thorburn has depicted here.

PLATE XI

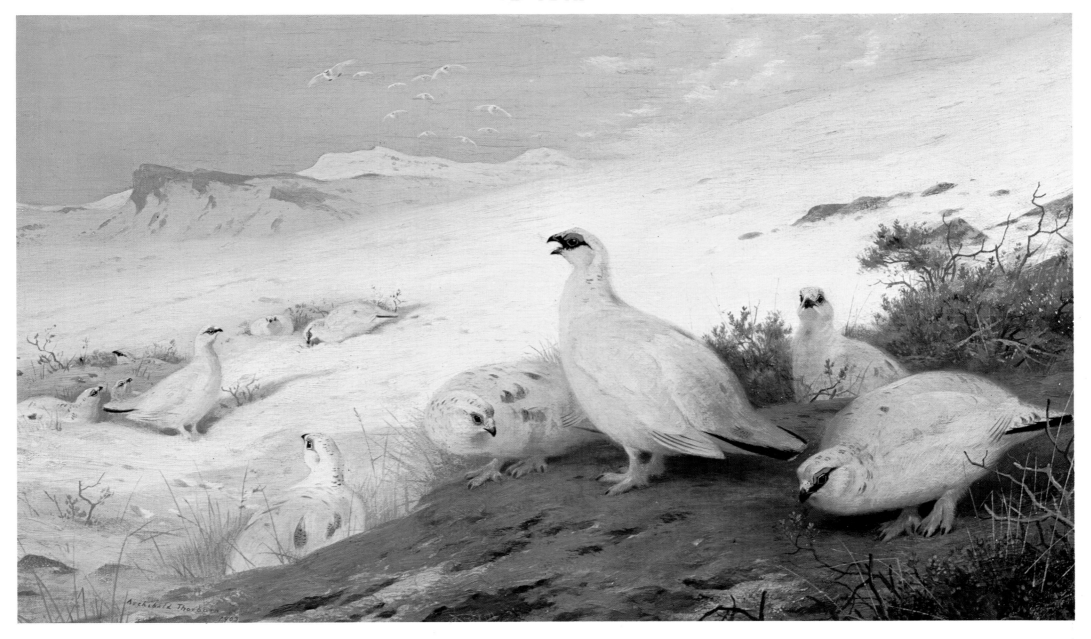

The Close of a Winter's Day
Watercolour 27$\frac{1}{4}$" × 63$\frac{1}{2}$" Dec. 1905

Slipping away over the edge of the world the sun bows out on a brief winter's day, brushing the woodland snows with a farewell glow of warmth as it goes. The pheasants, grateful for this fleeting cheer in such hard times, look on at the close of the day from a clearing in the covert and take their last meagre feed before retiring for the long night in the sparse comfort of their retreat. Early to bed, one bird is already tucked away in the brushwood beneath the snow-encrusted trees on the far side of the ride. Very soon now the wood will fall silent as the birds, roosting in bracken or branch, uneasily await the dawn.

In 1905 Thorburn received a commission for a large picture of pheasants in a wood in winter with the principal cock bird to be shown lifesize. This astonishing watercolour, unquestionably one of his finest achievements, is the result of that commission. Recollections testify that the work took some three weeks to complete, the preliminary sketches being made in Hascombe Woods. It is remarkable in many ways not least for its sheer size, which could well have proved a daunting task for a lesser mortal than Thorburn as the artist contemplated covering such a huge expanse of paper with watercolour. Although depicted life size, the cock bird

(Continued overleaf)

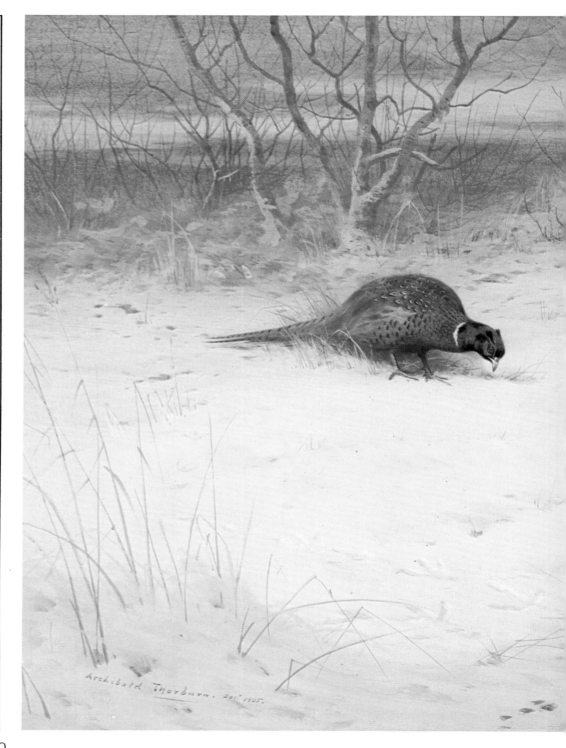

PLATE XII

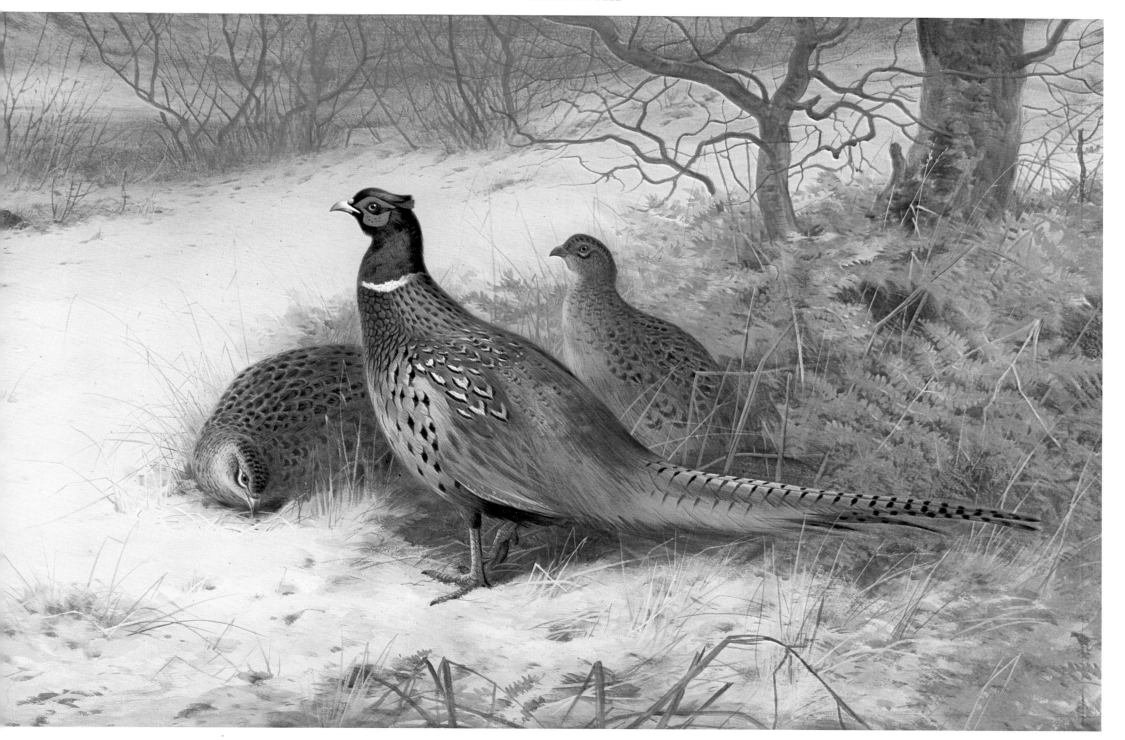

(*Continued from page 40*)
remains convincingly alive and alert, free from a stark map-like portrayal of its plumage; and, although this is a vast snow scene, the only pure white appearing in the entire picture is the ring around the cock bird's neck, as the expanse of snow is knowingly tinted and shadowed. Set against a spectacular winter sundown through leafless branches, the boldly-painted blue snow plastered upon the trees instantly brings a chilling realism. The artist's fidelity to nature shows in such touches of detail as his rendering of the deep footprints in the soft snow and the way in which the snow has drifted in upon the bracken, sprinkling it white.

Rarely did Thorburn do more than date his pictures with the year. Here, however, the actual month of completion as well as the year is recorded—Dec. 1905—as though chronicling a landmark in his life.

Autumn Alarm
Watercolour $17\frac{1}{4}'' \times 30\frac{3}{4}''$ 1900

The echo of a distant shot rings out crystal clear across the rolling hillsides and alarms the covey of blackgame, quietly feeding this autumn morning in the shelter of a heathery hollow. Hurriedly they rise and wing their way across the slopes, heading for a distant clump of birch trees behind which they swing and dip into the welcoming shelter of their moorland retreat, there to hide till danger passes.

A relatively early work, painted at the age of forty, this picture clearly shows the painstaking attention of the artist to bird and background at this stage of his career. From fronds of bracken to twigs and trunks of birch, the whole scene is painted 'tight' with a relatively dry brush, the work contrasting markedly with the much freer technique employed almost thirty years on with his outstanding *Danger Aloft* (page 103).

Blackgame are mainly vegetarians, though occasionally they will take beetles and ants. Their staple diet, however, consists of a wide variety of buds, fruits, and shoots, including bilberry, heather, birch, larch and pine, small grassland plants, and, of course, grain from the stubble and stooks in late autumn.

PLATE XIII

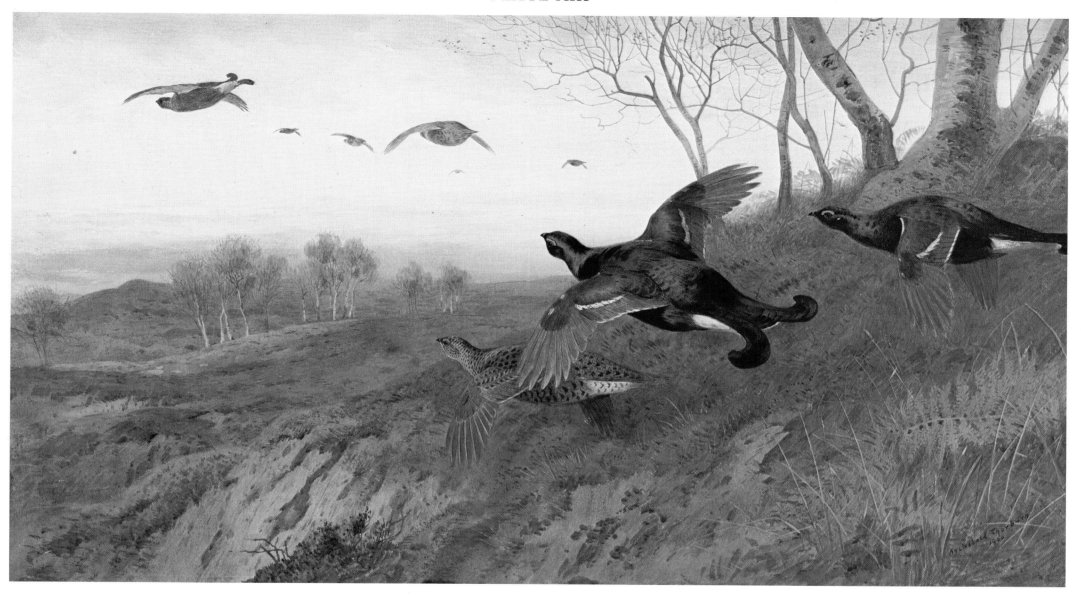

September Siesta
Watercolour $17\frac{1}{2}'' \times 30\frac{1}{4}''$ 1901

In the clear, bright stillness of a warm September day a covey of partridge rests. With harvest home, the labourers relax after their morning's toil, not a soul is in sight as the birds bask lazily in the last of the summer sun. The drowsy peacefulness has infected a passing goldfinch, who, perched on a nearby withering thistle, briefly settles to take its own well-earned siesta in the sunlit solitude.

Thus Thorburn captures the utter peacefulness of the scene and weaves into this fine watercolour the feeling of an all-round contentment, with well-fed partridge and goldfinch and man's harvest safely gathered in. His handling and portrayal of these lovely little gamebirds is sympathetic and gentle and shows his enduring compassion for such creatures. Many of Thorburn's compelling and beautiful scenes such as this one vividly remind us of a disappearing Britain, recalling for us the rolling undisturbed countryside of our forefathers, long before the combine harvester and bulldozer brought their pressures to bear.

Partridge eat a great variety of food even though they are essentially vegetarians. The bulk of their diet consists of seeds and leaves of many plants and grasses as well as grain, buds, and even flowers, but they also consume a variety of insects, slugs, earthworms, ants, and numerous larvae.

PLATE XIV

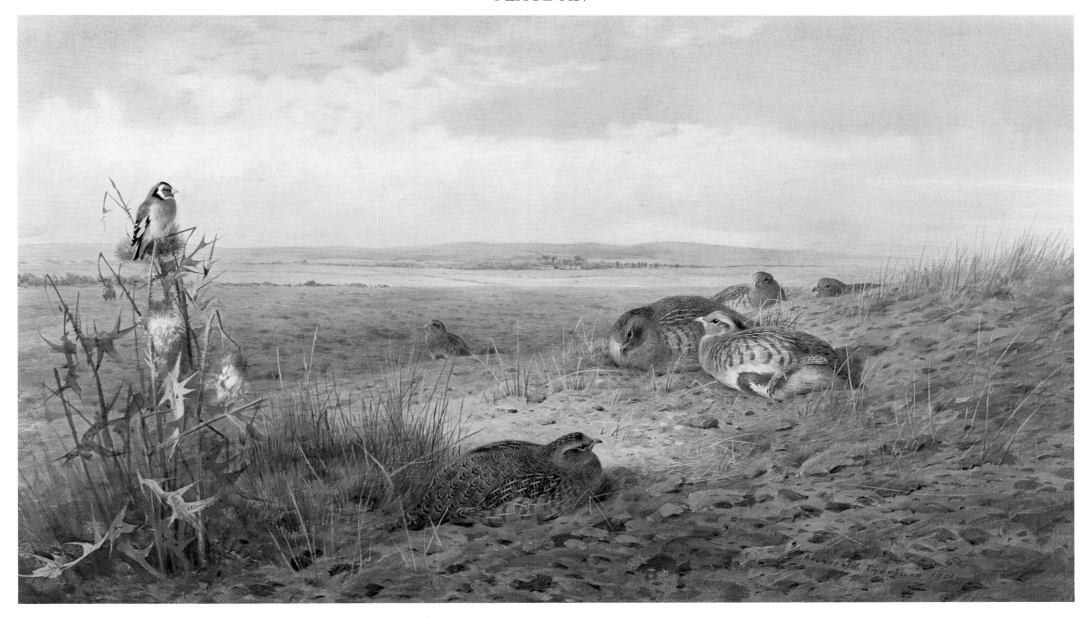

Killed as He Reaches Cover
Watercolour 20″ × 31″ 1906

With a masterly-timed headlong swoop, a peregrine falcon dispatches a drake mallard, bringing a dramatic end to a frosty winter's day on the fen. The peregrine, relentlessly hunting since daybreak to survive in these hard times, caught sight of the flock of mallard returning to roost in the reeds at the end of a day's feeding on the unfrozen water of rivermouth or seashore, and quickly closed in for the attack. The wildfowl, sensing the danger, made for the shelter and safety of the reed bed below with all speed and whilst most plunge on and live to tell the tale, for one drake mallard, alas, it is too late. Struck down by the feathered thunderbolt only seconds away from shelter, its neck instantly broken by the steely talons of the falling falcon, it plummets like a stone to the wintry reeds below.

In this painting, Thorburn has captured the amazing speed of the attack and the impact of the peregrine's talons on the mallard's neck with great distinction, as well as the fierce determination of the victor. When one considers that the incident passed in less than a second, one can appreciate the artist's skill at memorizing the scene, not only the broad outlines of victor and vanquished but also the precise position of wings, legs, heads, and feathers.

Thorburn was a great painter of atmosphere and temperature and in this particular painting, the setting sun's wintry glow upon the icy landscape is convincingly chilling.

The peregrine falcon spends the summer nesting on some high inaccessible cliff amongst the hills or overhanging the sea. But in autumn the birds forage further afield, being joined by immigrants from more northerly parts which tend to stake out a suitable hunting ground on fen or foreshore. They often remain there throughout the winter harrassing the wildfowl that have also arrived from more northerly, colder climes.

PLATE XV

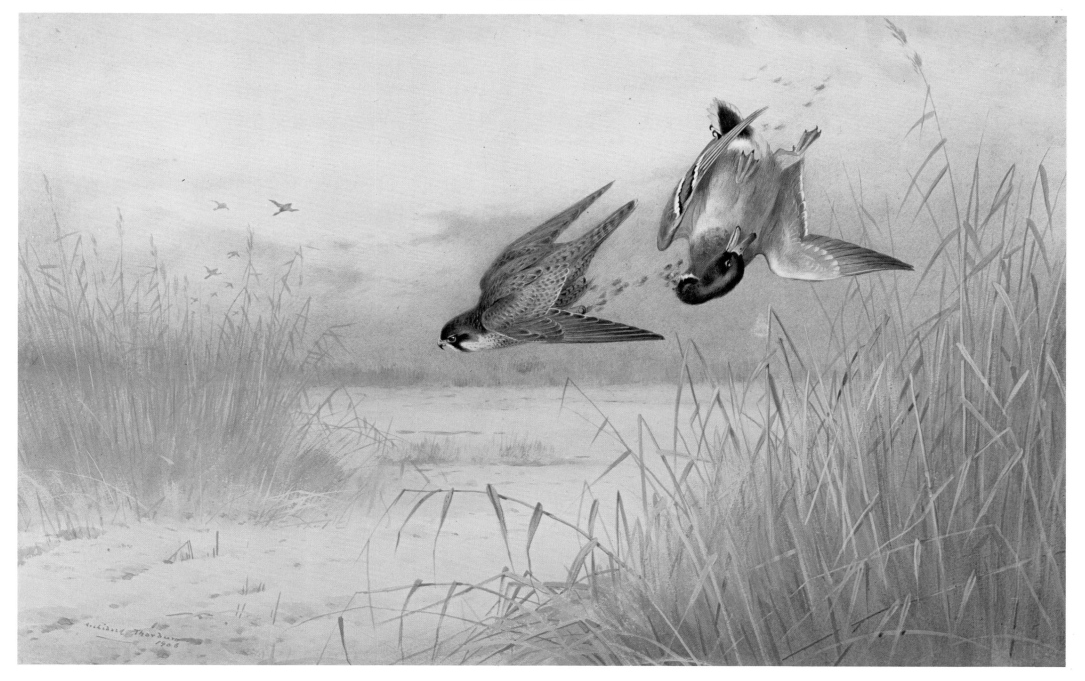

Goldcrests
Watercolour 11″ × 7½″ 1917

The faint sound of a squeaky wheelbarrow sorely in need of oiling, unexpectedly drifting down from the tree tops or from the dark seclusion of a clump of fir trees, announces the presence of Britain's smallest bird, the goldcrest. If it were not for this squeaky note, the tiny bird would usually pass by unnoticed. Flitting energetically from branch to branch, rapidly whirring from within the cover of one tree to the haven of the next, looking like an over-size bumble bee, it urgently probes out minute insects and grubs with which to replenish its tiny body with warmth and energy.

An attractive painting of a very attractive bird, capturing the delicacy of the creature nervously flitting its way through the equally delicate and graceful leaves and branches of a silver birch. The bird is very alive and stands out precisely against the beautifully controlled wash of the background.

The goldcrest is resident throughout the land and prefers woods of larch, pine, and fir. Its diminutive size is no match for a severe winter and in such conditions it suffers drastically, its numbers being greatly reduced. In fact, the extremely severe winter of 1916–17, just before this picture was painted, almost exterminated it from many parts of Britain. Since then it has, however, made a good recovery.

Common Squirrel
Watercolour 10″ × 8¼″ 1903

Scampering and springing with great agility through the ivy-clad branches of an old oak tree, a pair of common squirrels rummage for food. Stumbling across an acorn, one of them quickly severs it from the twig and, neatly holding the fruit with its front feet whilst balancing with its tail, skilfully nips away the husk with long needle-like teeth, much enjoying the kernel within.

A carefully executed painting, commissioned by J. G. Millais for his book *The Mammals of Great Britain and Ireland* published in 1904. Whilst fulfilling its prime function as an accurate scientific plate, Thorburn is still able to introduce action and movement and a sympathy for the subject into the work, resulting in a very living portrayal of these charming creatures.

The common squirrel is in fact, our red squirrel. In Thorburn's day the immigrant grey squirrel had not been introduced to our shores from America and the red squirrel was still common in our woodlands. Sadly, the more aggressive foreigner flourished and quickly spread far and wide, bringing about the virtual disappearance of our native creature as they competed for food and shelter in the same habitat. Woods in which red squirrels abounded in Thorburn's time have now been without them for many years.

PLATE XVI

PLATE XVII

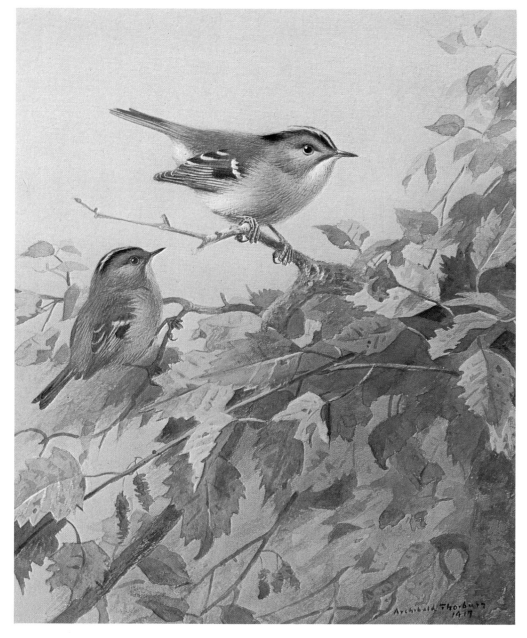

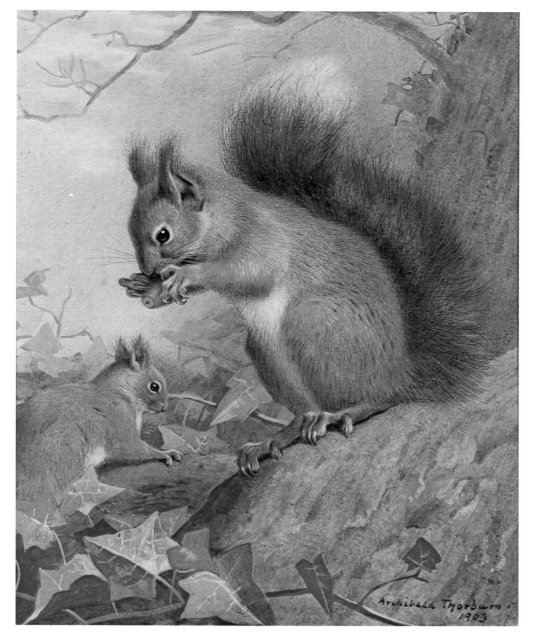

Sunrise over Gaick

Watercolour $21\frac{1}{4}'' \times 29\frac{1}{2}''$ 1904

High amid the snow-clad wastes of Gaick Forest, the winter sunrise revitalises the east-facing slopes with the day's first faint touch of warmth. Dawn mists are banished by the impending sunlight. Illuminating the distant icy peak, the early morning glow arouses the pack of ptarmigan, its bitter night upon the snows over; and, encouraged by the sun, the birds begin to preen and peck and stretch their wings as a new day unfolds. Other members of the pack, as yet untouched by any warming glow, huddle and doze unmoving amid the icy shadows, awaiting refreshment from the sun.

A difficult task indeed: commissioned to paint white birds in snow upon white paper, the artist has been asked to achieve the well-nigh impossible. But the situation is one which Thorburn knows well and he revels in the challenge before him. He deals boldly with the landscape, quickly putting in the clouds and snow-capped peak whilst bravely yet accurately tinting the foreground ptarmigan green as the snow reflects the shades of the herbage up onto their white plumage.

In the depths of winter ptarmigan feed and spend the day on the sunlit slopes of the mountains seeking the snow-free areas in preference to the deep drifts.

PLATE XVIII

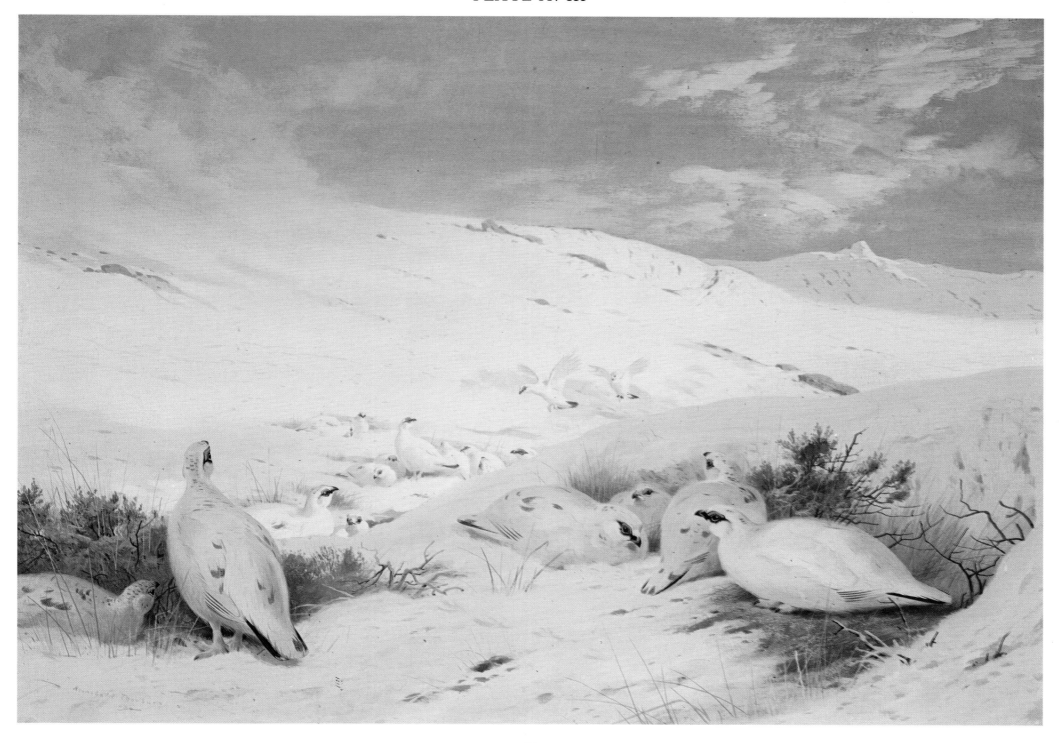

A Moonlight Night in the Open
Watercolour $21\frac{1}{2}'' \times 30''$ 1904

Under a starlit sky a covey of partridge slumbers away a crisp autumn night out in the open; squatting upon the empty stubble, heads out tails in, they await the dawn. One bird on watch, the rest asleep, the night ebbs steadily by. Without warning an owl looms like a ghost out of the mists that cling close to the low-lying land and hedgerows. The sentinel sits tight waiting to see which path the intruder will take. Should it swing towards them the look-out will promptly alert its companions, making them ready to scatter lest the intruder be an aggressor. But if it slips silently by, the covey will doze on, unaware, apart from the sentinel, of possible dangers passed.

Though a difficult and challenging work, produced from a limited palette of basically browns, greys, and sombre greens, Thorburn nevertheless admirably succeeds in capturing the stillness and the intensity of the occasion. The shafts of moonlight pick out the beaks of the birds and the hollow stems of harvested corn as the birds convincingly sleep. Lying upon his belly amid the stubble or bending behind a helpful hedgerow, the artist would first sketch the poses of the sleeping birds in his sketch books before embarking upon the finished work.

Partridges invariably roost or 'jug' in small coveys out in the open, well away from hedge or cover, and lie close together in a loose circle, heads turned outwards as Thorburn has shown. If disturbed they will scatter in all directions, foiling the intruder as well as avoiding collision amongst themselves.

PLATE XIX

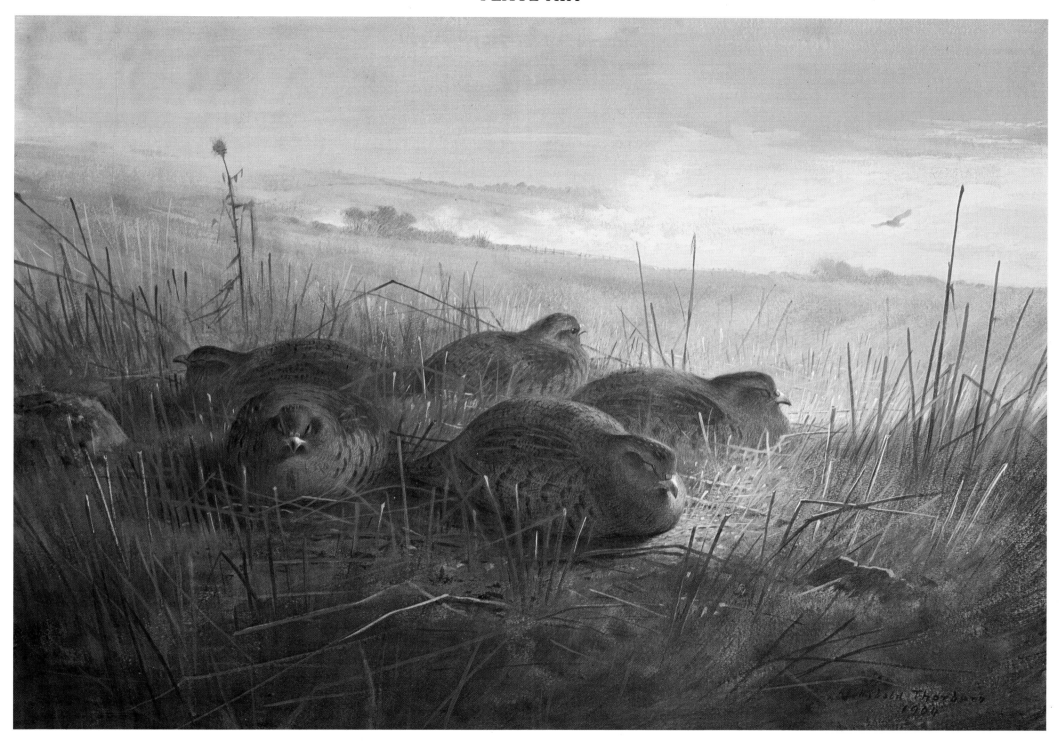

Winter in the Glen
Blackgame Packing
Watercolour $21\frac{1}{2}'' \times 15''$ 1906

A burnished sunset adds a welcome note of cheer to an otherwise bleak winter's day, yet at the same time foretelling the bitter night to come. Snow lies deep in the moorland hollow and clings precariously to the leafless branches of the scattered trees, impaled by the recent blizzard. Blackgame, returning unfilled from neighbouring snow-bound feeding grounds, glide in to the comfort of the haven, neatly twisting their bulky bodies through the outstretched branches. Earlier arrivals watch uneasily in the foreground as the sun casts a final warm glow over the chill carpet of the hillside. The birds are 'packing' for their mutual survival and will shortly take up their positions in the branches of the trees and sit out yet another long and bitter night.

Another example of Thorburn's skill in painting the back of a bird, for here the two main subjects of the picture are looking away from the viewer. The sun's rays reflected from the snow upon the birds' plumage are sensitively executed, as is the overall tinting of the snow. The middle footprint, heading directly up the page, is a well-nigh impossible task for the artist. He succeeds, but how much easier he could have made life for himself had he cheated on what he had seen in nature and indicated that the bird had moved in from the right.

Capercaillie
Watercolour $13\frac{1}{2}'' \times 10''$ 1926

S wiftly and silently, a pair of these huge gamebirds have just returned to the safety of a lofty lookout on the edge of an ancient forest of Scots pine. They have spent the day with others of their kind, feeding amongst the berries and shoots on the vast expanse of adjoining heathered hillside, but now, acknowledging the approach of sunset, prepare for the night roosting high above the forest floor.

The technique is typical of Thorburn's illustrative work: the birds freely finished and not overlaboured, as is so often the case with recent artists of limited field experience, resulting in a lifeless and unreal map of a bird's plumage. The quick generalisation of the background, whilst accurately indicating the habitat of the species, forms a subdued backcloth to the birds themselves. Just to add interest, the artist gives us a clue as to the time of day, though allowing us to make up our own minds as to whether it really is dawn or sunset.

The old original stock of British capercaillie became extinct in Scotland about 1769. Reintroduced from Sweden to the woods by the River Tay in 1837 by the Marquis of Breadalbane, this stock soon multiplied and today capercaillie are found thinly throughout favourable localities in Scotland, preferring mature and often remote woodlands of Scots pine, larch, and spruce.

PLATE XX

PLATE XXI

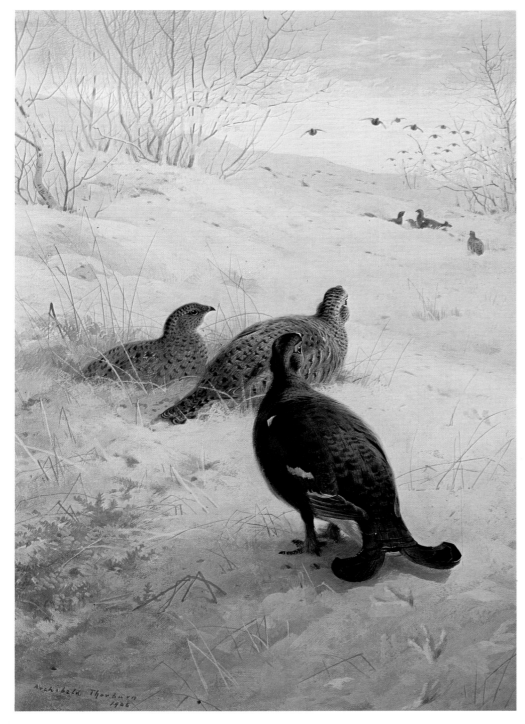

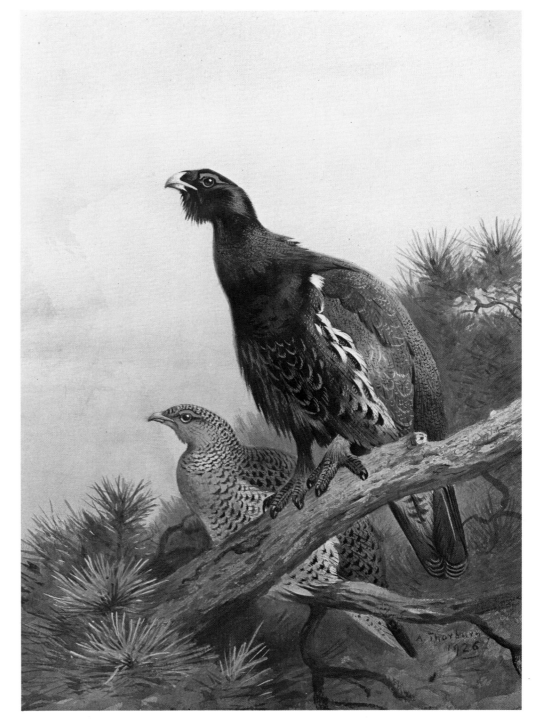

Startled

Fox in the Snow
Watercolour $7\frac{1}{2}'' \times 10\frac{1}{2}''$ 1909

Amid the wintry wastes of snow-clad hills, a fox plods on single-mindedly, urgently seeking sustenance before yet another night of snow. Startled in its path by some faraway echo borne upon the stillness, it halts and, standing motionless, one leg held transfixed, alertly assesses the situation before continuing upon its way.

Thorburn chillingly recaptures the bleak austerity of that winter's day, depicting with awareness the vibrant alertness of the fox, intent only upon survival.

Whilst he seemingly has few friends and many enemies, the fox continues not only to survive the onslaught of general persecution levelled at him but actually to prosper and indeed multiply in the face of such adversity. His cunning and astute adaptability to the changing landscape of Britain are the main reasons for his success. Reluctant to retreat and flee his domain of wood and common, he remains entrenched before the advancing sprawl of urban concrete, taking advantage of man as he raids and scavenges livestock and refuse.

PLATE XXII

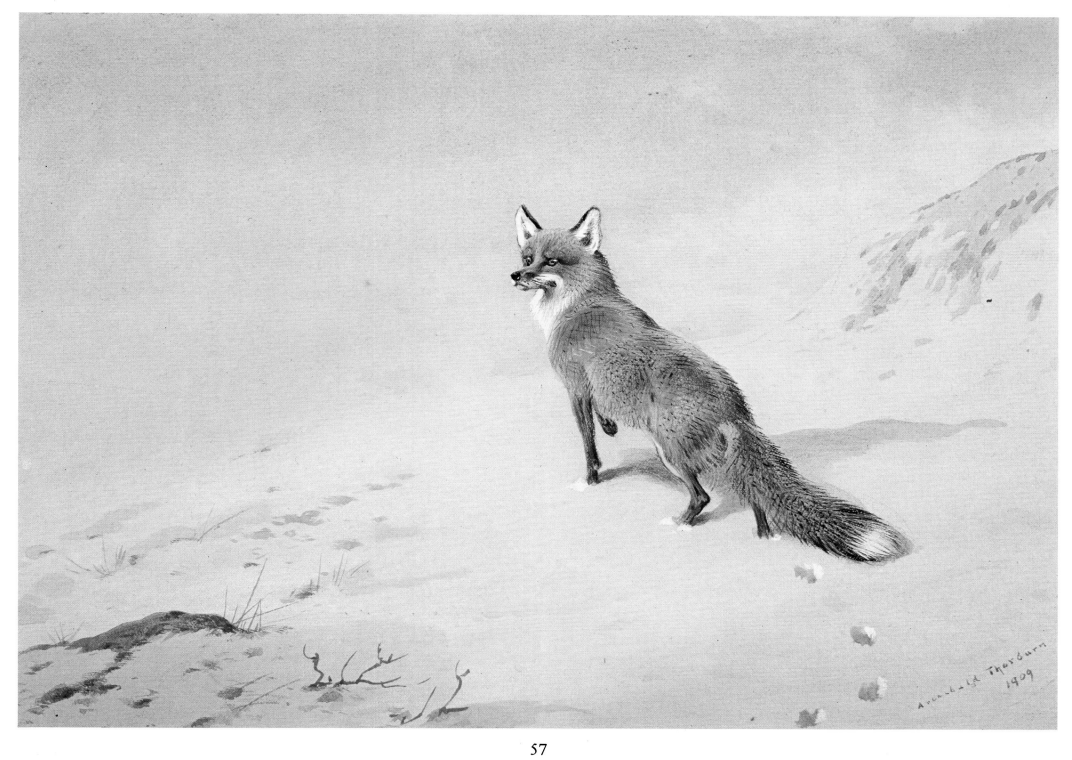

Blackgame in the Birches
Watercolour 11″ × 15″ 1909

As evening closes in across a Scottish moorland, black-game wing their way homewards to the shelter of the silver birches. Full-fed from a fine autumnal day's browsing amid the berried harvest sprawling over the nearby slopes, they now regroup ahead of the setting sun and begin to 'pack' together for protection high in the swaying branches in which they will pass the crisp autumn night.

With the possible exception of woodcock Thorburn loved blackgame more than any other bird, revelling in the challenge of capturing faithfully with brush and paint the glorious sheen on the blackcock's neck and back and the wildness of the terrain in which they lived. The rich russets of autumn, with sunset sky and lacey, silvery trees are very typical of his work and reminis-cent of the places he loved most on earth.

The male and female black grouse are respectively known as the blackcock and the greyhen. Collectively they are commonly referred to as blackgame. Wild and wary, they are for the most part difficult to approach, quickly whirring away over heather-clad hillsides if disturbed and adroitly twisting their way through trees as they reach cover.

Blackgame nest on the forest fringes, in sheltered clear-ings close to scattered clumps of birch, larch, or pine. Towards the end of September with the breeding sea-son over, they begin to congregate in packs, sometimes in considerable numbers, cocks and hens together, feed-ing on the oat stubbles of the adjoining arable land in the valleys or the blaeberries or heather shoots on the higher slopes. At dusk they return to roost within the shelter of the birch woods in the folds of the hillsides.

PLATE XXIII

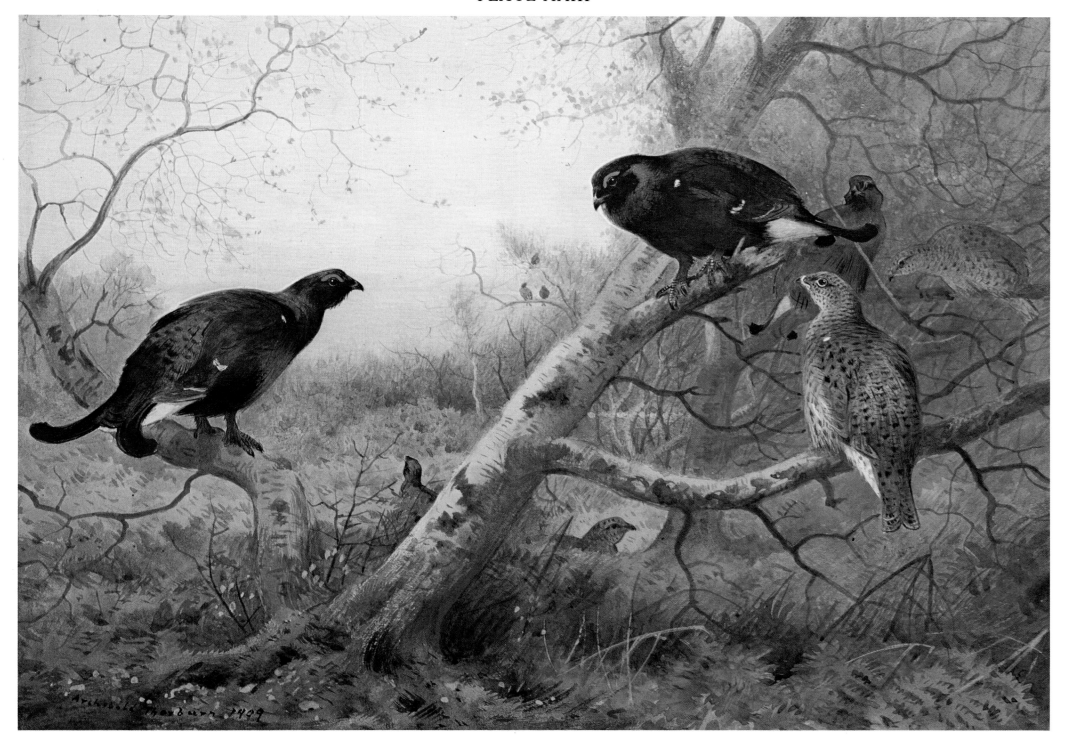

The Home of the Red Grouse
'moors red-brown wi' heather bells –' (Burns)
Watercolour 22″ × 30½″ 1910

Out of a fold among the purple-clad hillsides a covey of red grouse emerges in rapid flight, the birds whirring their way towards a neighbouring covey taking its ease on the brow of the hill. As the passing clouds spread quick-moving shadows across the rolling slopes below, the birds relax for a while on this warm autumn day amid the heather, their home throughout the year.

Even without the birds, the picture is a lovely representation in watercolour of the richly-coloured Scottish hillsides in the fall of the year. Thorburn's expert use of light and shade forms the undulations of the hillside and sharp-edged ridge, painted in subtle tones against which to place the foreground of bold red-brown birds in brightly-blooming heather. To draw attention again to his fascination with the back of a bird, surely none has yet been painted to surpass the lovely, round, solid bird on the right of the picture, intensely alive, a gem of ornithological painting.

Red grouse are sociable birds and as autumn turns to winter the scattered family coveys converge into packs and forage together over the wide moorland slopes. They also roost together, perhaps a foot or so apart, in sheltered hollows amid the heather. When besieged by a severe spell of weather, they will feed by tunnelling beneath the snows to locate heather tips and other vegetation, whilst in blizzard conditions they avoid being buried alive by the heavy snow by actively trampling it beneath them as it falls.

PLATE XXIV

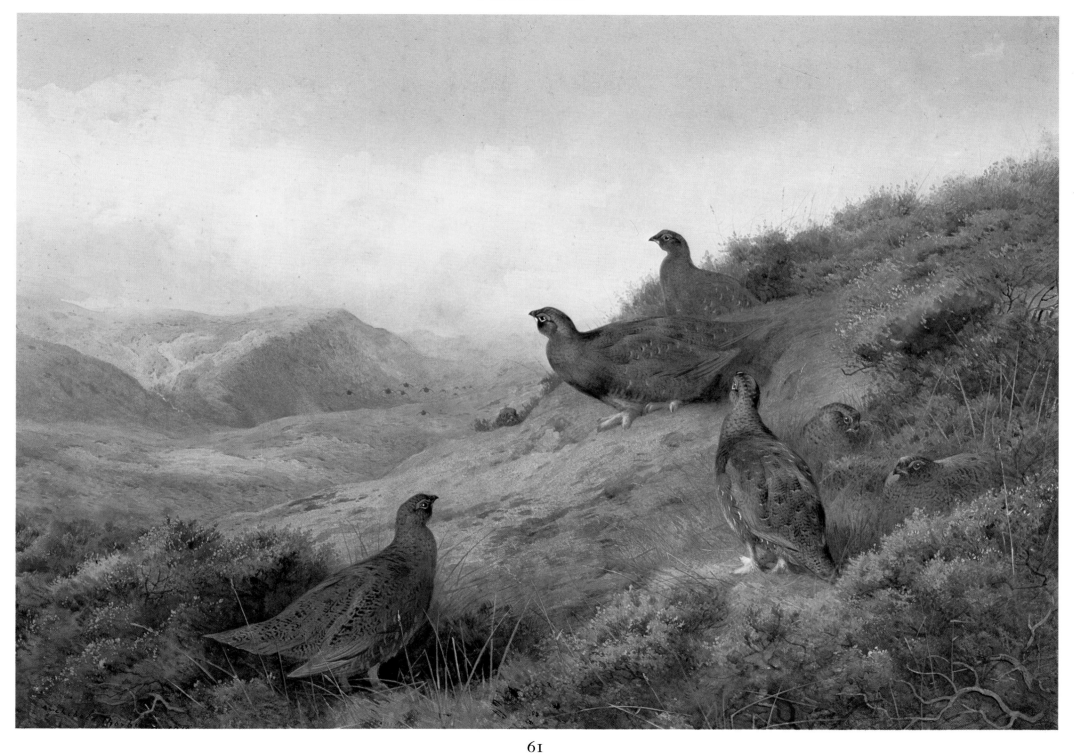

Watched from Afar

Watercolour 22″ × 30¾″ 1910

The burnished foliage of the larches and the berried briar foretell the close of the year. All is tranquil in the warm morning sun as a small group of pheasants feeds peacefully on a pathside close to the edge of the covert. Suddenly, the old cock bird, ever watchful, glimpses two huntsmen approaching in the distance. At his command the two hen birds crouch instantly and a jay, lured by the warm sunlight to forage away from the confines of the wood, hurriedly takes wing at the sentinel's call and beats a hasty, though far from silent, retreat into the depths of the silent copse. Unflinching, the cock pheasant watches intently from afar, as the horses and their riders wend their way towards the edge of the wood, abruptly veer into a sunlit glade and silently disappear, returning the scene to serenity.

The magnificently painted cock pheasant set in a glorious autumn landscape, recalls times past as we notice the unkempt ground, refuge for plant and butterfly as well as bird, long since devastated by bulldozer or plough, and reflect upon the unspoilt and unhurried times at the turn of the century. Thorburn, now fifty, displays all his craft as a watercolour artist—highlighting just the right number of grasses and showing us how to cope to perfection with the rendering of the back of a hen pheasant. His observation of nature is well expressed in the split top of the larch tree, broken either by squirrel or storm, and the lovely patch of sunlight laid out beneath the right-hand larch trees, guiding our eyes the way the riders went.

PLATE XXV

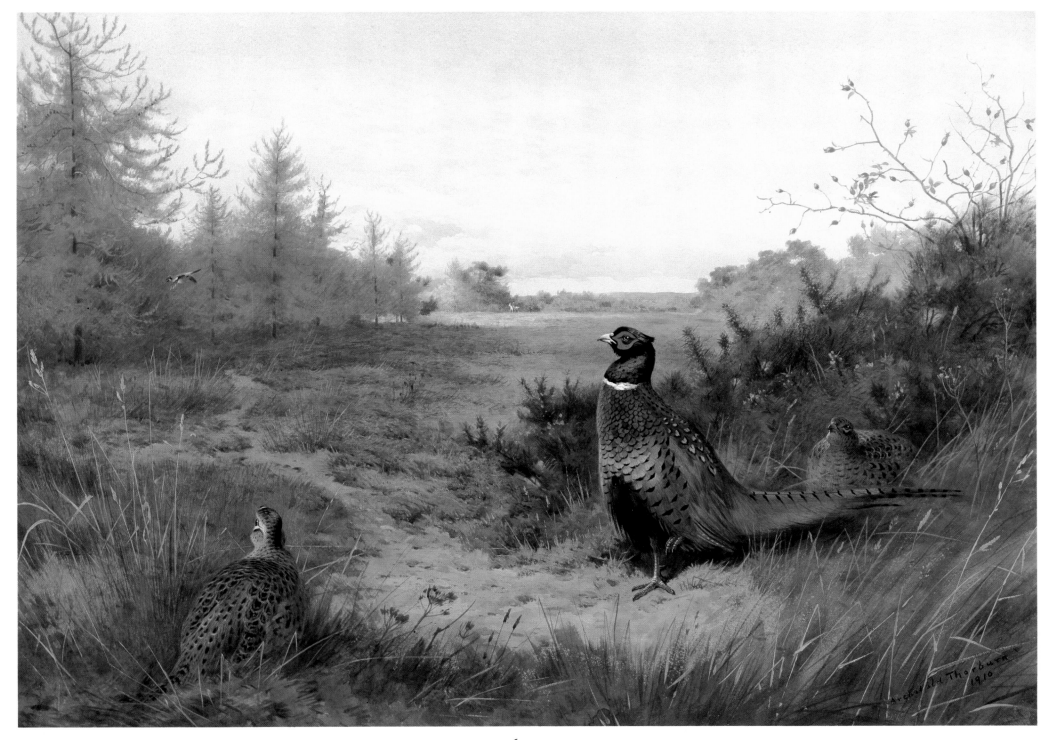

The Bridle Path
Watercolour 22″ × 29¾″ 1910

Ablaze of burnished bracken and leaves upon the ground foretells the fall of the year. In sanctuary beneath the sprawling cloak of the gnarled old oak tree and warmed by the sun's shimmering rays upon the canopy of golden leaves, a group of pheasants feeds lazily in a sunlit glade. Relishing the autumnal seclusion at the edge of the bridle path, one bird has meandered away from the others and forages alone on the far side of the ride. The utter tranquility of the occasion is abruptly shattered as a jay wings into view and, flying swiftly by, voices its raucous warning as it delves for shelter deeper in the wood. Almost at once the intruder appears—a huntsman scarlet-clad upon his horse—and framed in the leafy awning crests the rise in the path before swiftly cantering forward. The pheasants, alarmed by this sudden intrusion, crouch and prepare to move into cover, the strayed companion nervously running down the bank to join his comrades in their scuttle for the bracken, there to squat and hide till danger passes.

Thorburn loved this spot, deep in Hascombe Woods a mere ten-minute stroll from his house. He visited it on innumerable occasions armed with a field-glass and sketch book and knew every detail of it intimately. He knew the gnarled oak tree and the slender sapling grow-ing up under the old one's wing, and he produced several very fine finished watercolours based on happenings here. In other pictures we see a fox or another pheasant crossing the path where the huntsman appears in this one, and another example has a group of pheasants in rapid flight past the ancient tree.

With pencil and paper, Thorburn was intently drawing the group of pheasants feeding in the wood. Disturbed by the sudden intruder, he could well have thrown up his arms in dismay and gone home but he chose to capture the turmoil with great dexterity, ultimately turning near disaster into triumph.

PLATE XXVI

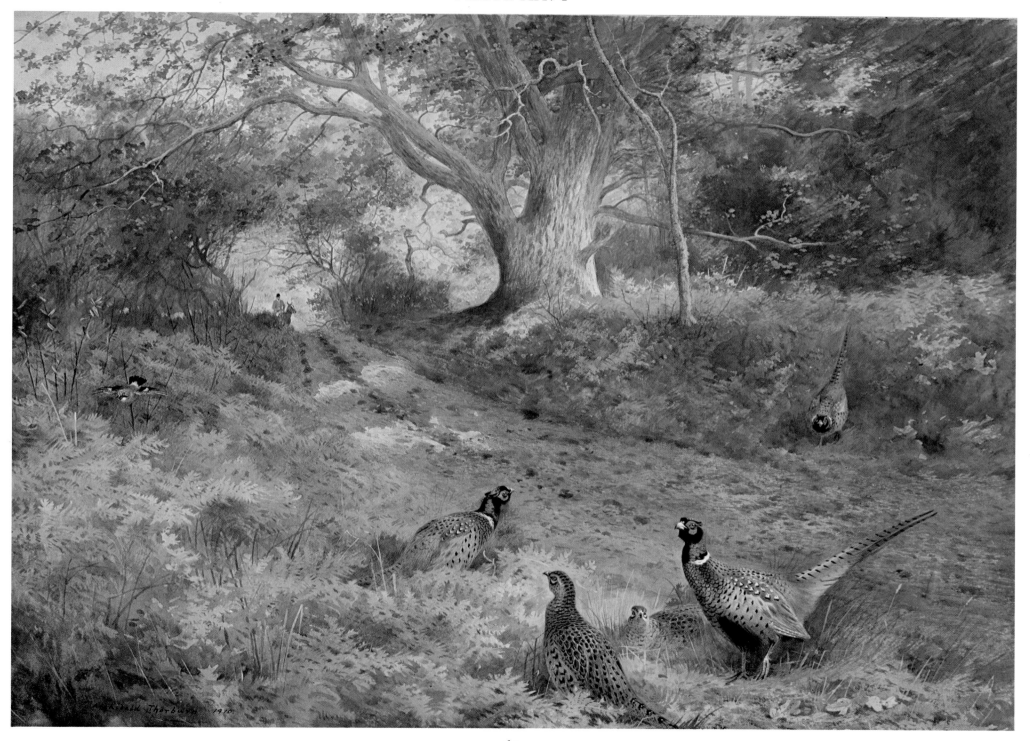

The First Touch of Winter
Watercolour 11″ × 15″ 1910

Beneath the snow-laden trees at the fringe of the covert, a small group of pheasants feed as best they can after the first fall of snow of winter. Still slightly uneasy at the sudden transformation of their haunt by the unexpected heavy fall, they resign themselves to the situation and prospect silently through the white mantle, anxious to replenish their crops before winging their way to roost amongst the firs, as another brief day ends.

With bending branches and snow-covered ground, Thorburn expertly sets the scene for the pheasants' struggle for survival during the winter months. The cleverly placed and coloured sunset adds drama to the scene as well as drawing one's eye right across the picture, along the woodland path and on towards the setting sun.

The pheasant was most probably introduced to Britain by the Romans, brought by them from the Black Sea area of the Caucusus between A.D. 50 and 400. In the middle of the eleventh century pheasant appeared on the menu of the monks of Waltham Abbey but it wasn't until the eighteenth century that it had become widespread in areas of suitable habitat throughout the land.

PLATE XXVII

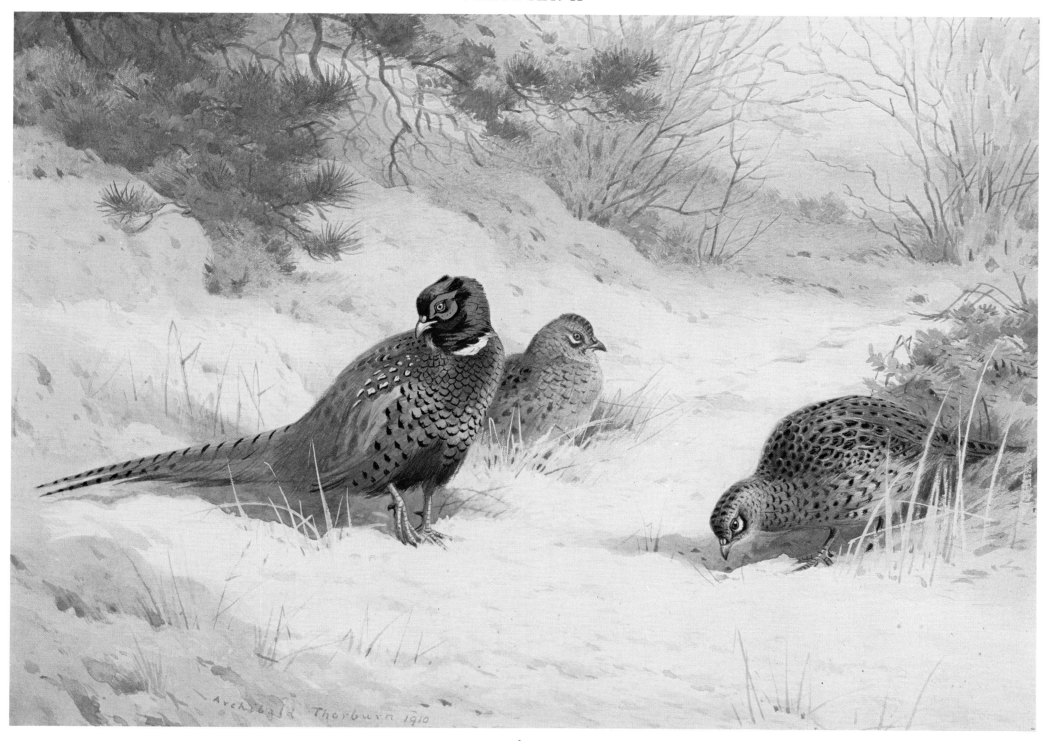

When the Gloaming Comes
Watercolour $22\frac{1}{4}'' \times 30''$ 1912

Settling down amongst the purple heather, a covey of red grouse makes ready for the approaching twilight. At the end of a perfect day, the retreating sun glints upon the distant loch and frets the ridge with waning rays. As it goes, it tints the covey quietly observing the end of the day from its hill-top roost, as the mists roll in from the sea.

Here Thorburn revels in the colours of such a scene. With setting sun upon bird and bloom, his execution is bold and purposeful resorting to practically every colour in his palette to capture the warm serenity of the gloaming. He produces some remarkably alive and well-shaped birds and copes admirably with the foreshortening, particularly on the squatting left-hand bird.

Red grouse nest amongst the heather, usually in a shallow scrape sheltered by ling or grasses and lined with dry grass or moss. Seven to ten eggs are laid. On hatching some three weeks later, the chicks are quickly led away by the hen bird, usually with the cock bird on guard nearby.

PLATE XXVIII

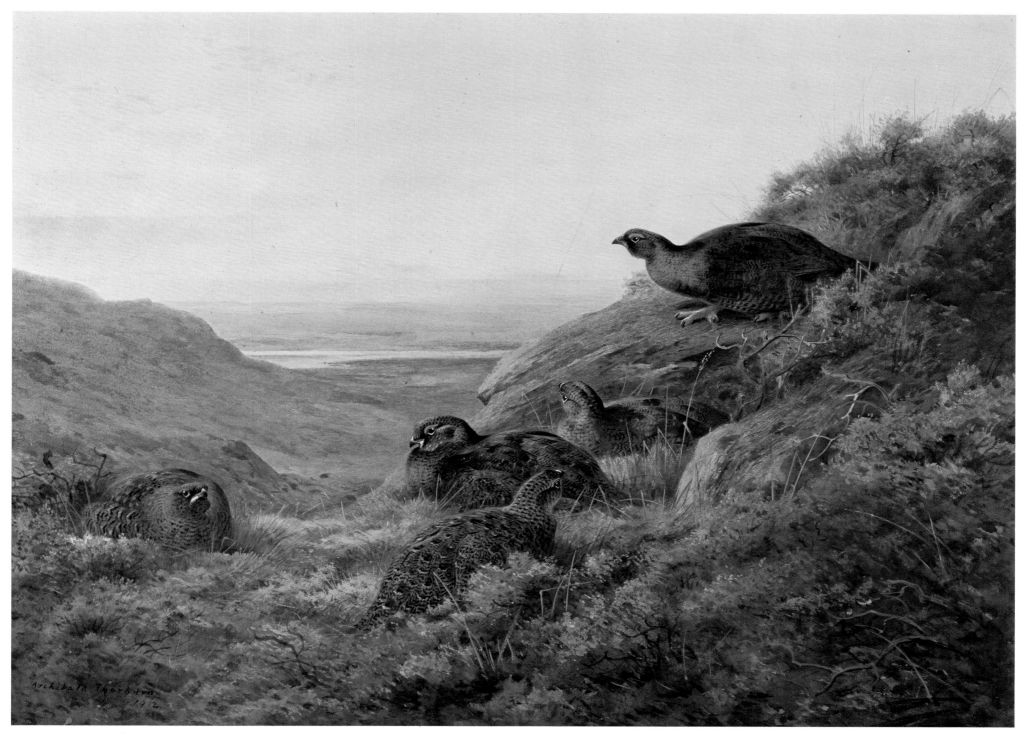

Voices of the Forest
Watercolour $21\frac{1}{2}'' \times 30''$ 1912

Casting cool shadows as it fades, the sun dips behind the hill-tops in the Forest of Gaick in Inverness-shire, and the evening mists begin to fill the cauldron below. The voices of a lone red deer stag, roaring his presence across the great curving arena, and of a skein of high-flying geese gaggling noisily as they return from their farmland feeding grounds to the safety of the sea-shore away in the west, mingle eerily across the vast solitude of a Scottish deer forest.

In this lovely free composition, capturing so well the grandeur of the Highlands the artist is sufficiently confident and competent to place the stag looking into the picture and not out of it, thus creating a difficult exercise in perspective. The great cloud effect is again achieved, as in *Danger Aloft*, by laying on and then removing some of the colour with a cloth, skilfully rubbing away a section of wet paint to produce the stag's breath upon the evening air.

Though generally shy and elusive, wary of man for most of the year, during the rutting season in the autumn the red deer stag becomes much more bold and defiant whilst challenging some distant rival away across the glen with a far-reaching roar.

PLATE XXIX

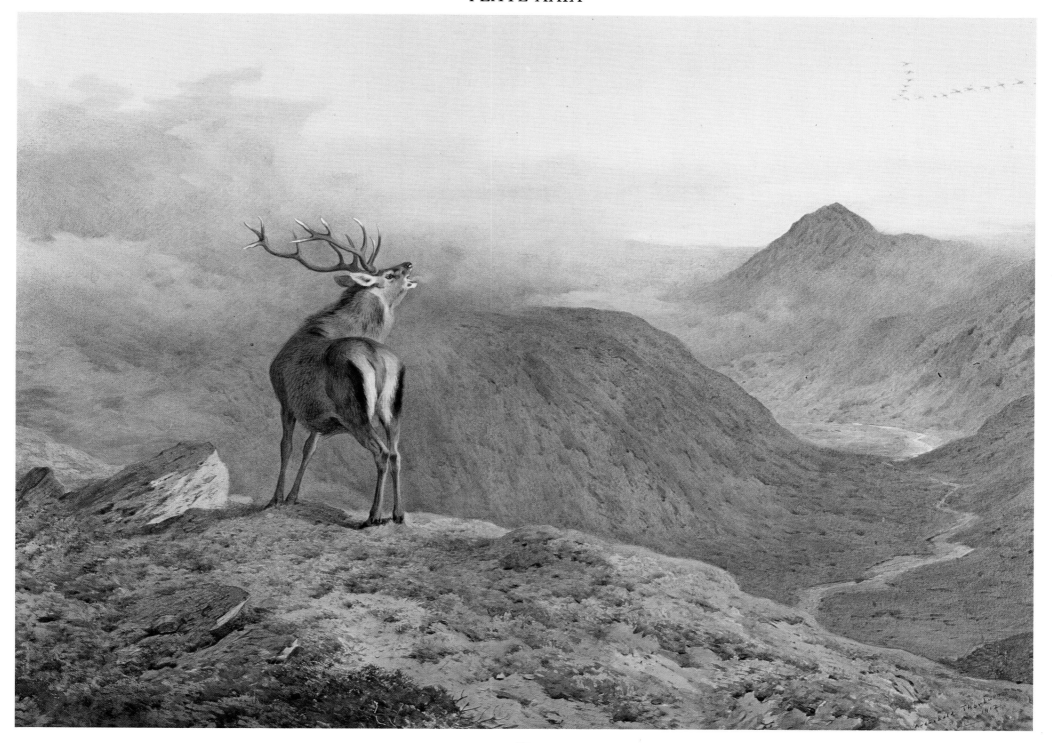

Ptarmigan at Sunrise
Watercolour $14\frac{1}{4}'' \times 21''$ 1910

Like snowflakes drifting in over the crags, a small pack of ptarmigan noiselessly glide down to swell the ranks of a neighbouring pack still awakening slowly as the tinted glow of the snowy wastes heralds the arrival of another day. Arousing from their long night in such a high and inhospitable place, they begin to forage for meagre morsels as the old cock bird voices his greetings to the early morning visitors.

The blue-tinted birds in the blue-shadowed hollows set against the most subtle of sunlit glows upon the snow, dramatically emphasise the starkness of the scene and chillingly convey the rigours of such an existence to those of us who have never braved it for ourselves, even by day.

Ptarmigan are basically staunch vegetarians, only occasionally feeding on insects and grubs. Eating mainly shoots and leaves of heather and blaeberry and the like, they are also partial to the berries of such moorland plants. In summer, they tend to feed mainly in the early morning and again in the evening, but in winter will seek out sustenance throughout the day in their struggle for survival.

PLATE XXX

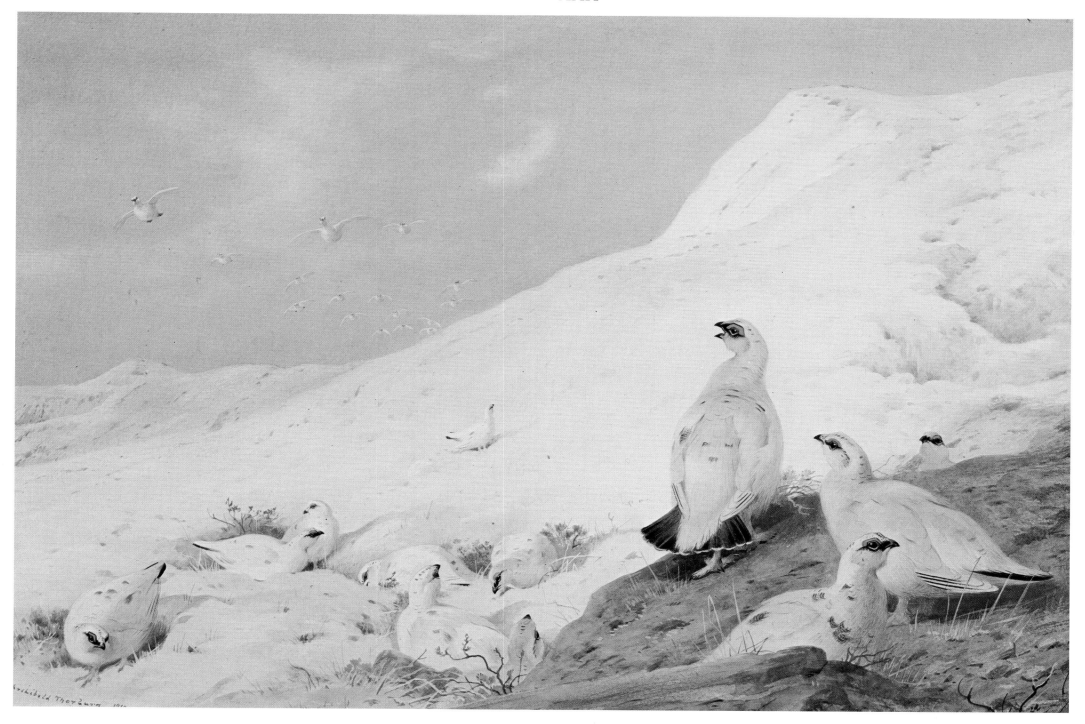

Ptarmigan
Watercolour 11" × 15" 1923

Sheltering on a sunny slope almost at the head of the glen, a covey of ptarmigan takes its ease dozing and preening amongst the harmonising vegetation and weathered rocks of the surrounding grandeur. On the far side of the ravine a herd of red deer forages, the animals steadily wending their way down from the comfortless and eerie mist-clad tops above to continue their quest on the more congenial slopes below.

A typical watercolour from perhaps Thorburn's finest period. Here, at sixty-three, he is a master of his craft and flows the hillside tints on wet and with ease, rapidly changing colour as he goes, deftly highlighting certain features such as a stone and leaf from the background series of washes to complete the effect. Clever placing of shadow behind bird and boulder quickly transforms the work into a living three-dimensional scene from nature. And the depth and movement of the swirling clouds away in the corrie above are painted by a master of watercolour for pupils to endeavour to emulate.

The ptarmigan is a bird of the wild and inhospitable high tops of Scotland, which are sparse in vegetation though plentiful in wild and cheerless weather. The bird's changing plumage in harmony with the seasons renders it hard to find at all times amongst the rock-strewn landscape or the snowy wastes of winter.

PLATE XXXI

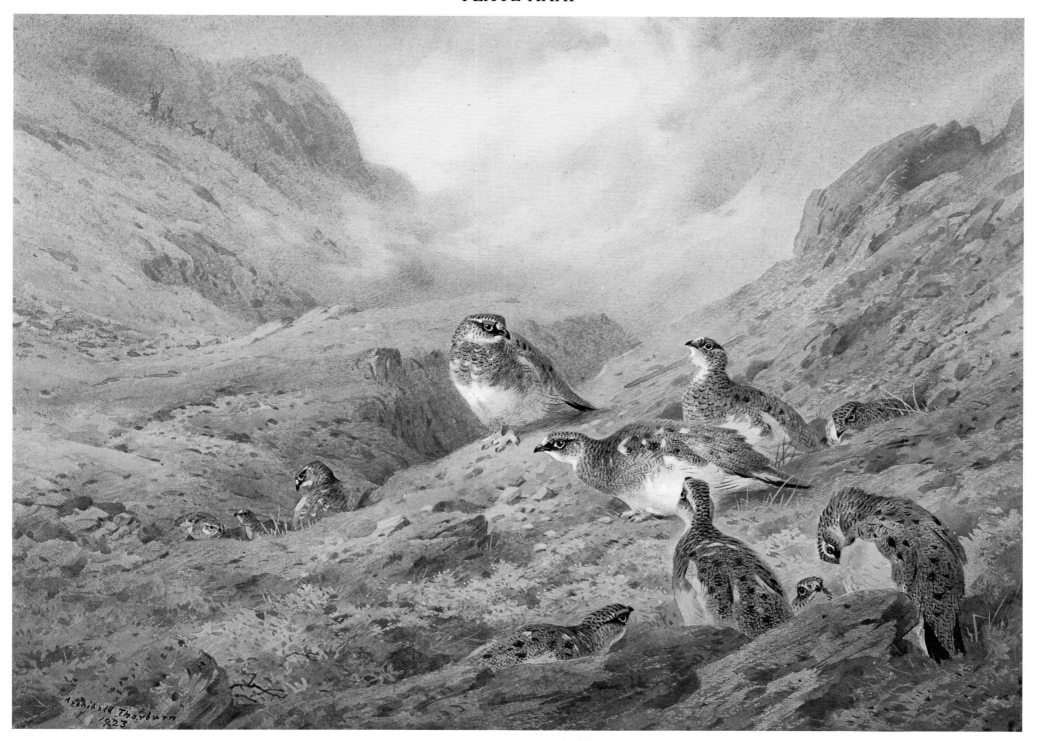

Victor and Vanquished
Watercolour 11″ × 7½″ 1913

Death came swiftly to the winter blackbird. One moment feeding on a berried hedgerow and the next snatched from his tranquility by the unexpected and terrifying iron grip of the sparrow-hawk, swiftly scouring thicket and copse for just such prey. Carrying his prize to a quiet place, the hawk drops down silently into the soft snow and carefully begins to pluck his plunder, the ebony feathers standing out starkly as they flutter onto winter's white carpet.

This is a remarkably economical piece of painting, for although the birds are carefully formed and painted, the landscape is but hinted at, deftly conveying the starkness of winter.

The sparrow-hawk is widely distributed throughout Britain wherever there are woodlands. It flies fast and low when hunting, silently slipping from one side of a hedge to the other, trusting in surprise to bring about the downfall of some unsuspecting prey.

The Eagle Owl
Watercolour 11″ × 7½″ 1917

Welcoming the approaching nightfall, the eagle owl emerges from his daylong den deep in the sanctuary of the forest and, roused from his slumbers by the ebbing light, slips out to sit sleepily on an eminence, surveying his hunting ground for a while before setting out to begin the night's prospecting, silently gliding over the forest fringe in the gathering dusk.

Although this was almost certainly a private commission for a small picture of an eagle owl, Thorburn deftly tells us something of the life of the bird as well. The lovely subtle background wash, capturing so well the hushed sunset over the forest, sets the scene for the nightly emergence of the owl from the woodland to hunt.

The eagle owl, only a rare visitor to Britain, is a bird of the wooded and mountainous areas of northern Europe, breeding as far north as the Arctic Circle in Sweden, Finland, Norway, and Russia. The largest of the owls, its immense strength renders it capable of capturing and killing young deer, as well as hares and squirrels, and it can overpower birds as large as the capercaillie without undue difficulty.

PLATE XXXII

PLATE XXXIII

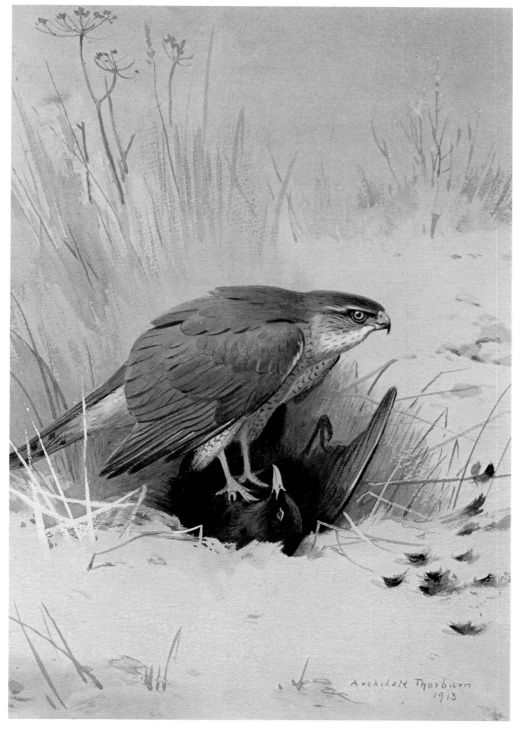

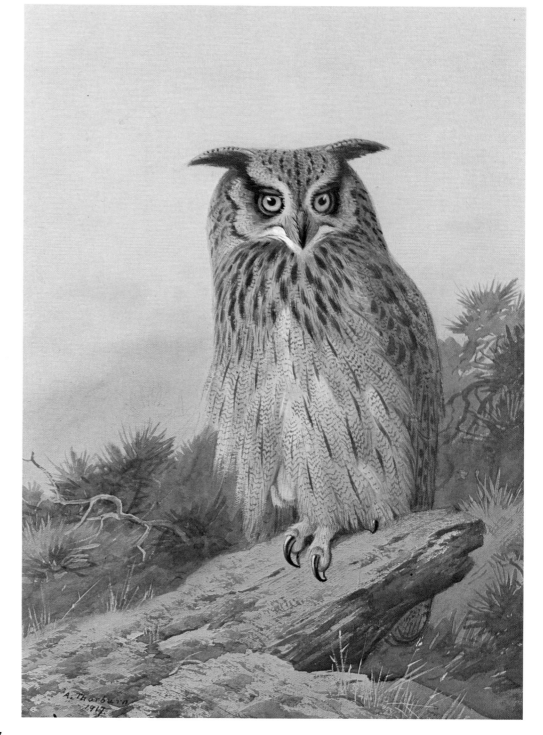

Blackgame
Oil $11\frac{3}{4}'' \times 19\frac{1}{2}''$ 1903

Another bitter night is nigh. Under a snow-laden sky, a lone blackcock hurriedly wings his way homewards to the sanctuary amid the snow-capped trees before dark finally closes in. Other blackgame, home early from their frost-gripped feeding grounds, have already staked out their resting place for the night amongst the fallen birches and, huddled motionless and resigned to such rigours, begin to sit out the long night making the best of such cheerless times.

Thorburn did not enjoy painting in oils and found the medium difficult to handle compared with his beloved watercolour. He complained that birds painted in oils by others and himself, looked heavy, solid, and lifeless and one was unable to capture the softness and delicacy of feathers as well as with watercolour. This particular picture and its companion on page 39 were commissioned as a pair in 1903 and this one particularly is very successful.

Blackgame used to be widespread throughout our islands, but since the turn of the century their numbers have been decreasing in England and they are now totally absent from many parts. Still to be found in the forest areas of north Wales, they continue to be widely distributed throughout Scotland though here too their numbers are declining seriously.

PLATE XXXIV

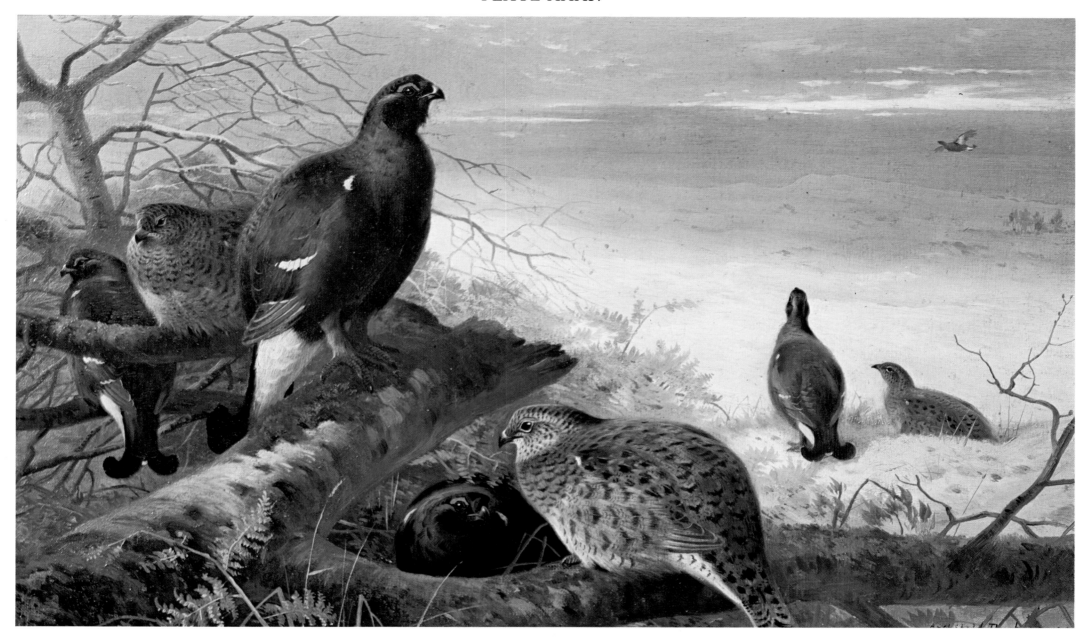

Winter Woodcock
Watercolour $7\frac{1}{2}'' \times 11''$ 1916

Undaunted by the frost, a pair of woodcock endures the continuing hard spell of winter with quiet determination. Reposing in the stillness of the silvery covert, they remain ever attentive for the first faraway echo of approaching danger, borne upon the silent air.

Whilst the birds themselves are magnificently painted, this particular landscape illustrates very well Thorburn's gift of generalisation. Sections of the sheltering vegetation are neatly transformed into bracken simply by the deft placing of darker brown shadows. The bleakness of the frosty background is made more effective by the few bare branches in the middle distance on the left-hand side and the omission of all other detail.

Woodcock will spend much of the daylight hours resting secretively in some favourite woodland glade, seemingly aware of the protection afforded by their russet feathers as they mingle with fallen oak leaves and withering bracken. In snow, however, they will snuggle closer to a fallen log of birch or larch or beneath a frond of bracken that escaped the falling snow, thus camouflaging themselves against the eye of some unwelcome visitor.

PLATE XXXV

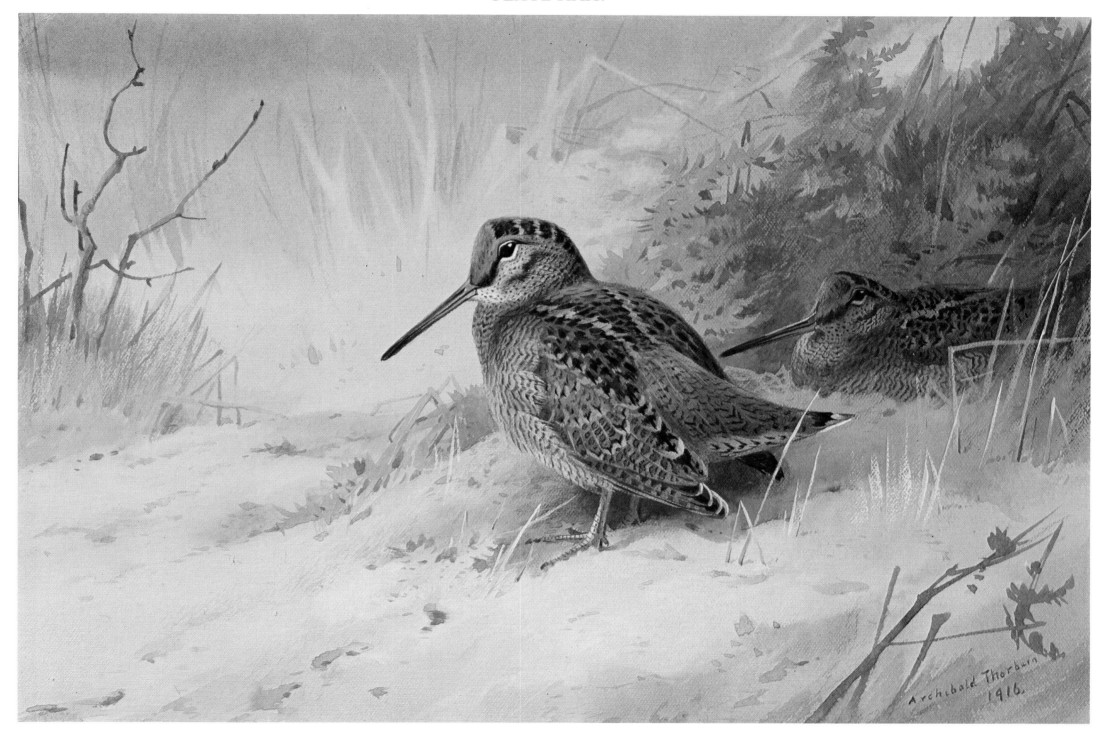

The Hare
Watercolour $12\frac{1}{4}'' \times 15\frac{1}{2}''$ 1919

Cresting a hill-top, a mountain hare diligently scans the unfolding countryside below. With eager nose and quivering whiskers, it stands well-nigh motionless, eager to catch the faintest whisper or taint borne upon the silent air. Wary of eagles and of man, it pauses momentarily, reassuring itself all is well, before gingerly continuing upon its way over the rock-strewn landscape of the high ground.

A really lovely example of Thorburn's skills as a watercolourist. The animals—so vibrantly alive one almost expects to see the nose and whiskers twitch—are set off to perfection by the brilliantly laid on wash of the background. Painted on pale green tinted paper, the animals are not overfinished even though it was painted as a scientific illustration for his book *British Mammals* published by Longmans in 1920. A study of the Irish hare is shown in the background. When the work was all but completed, courage as well as craftsmanship was called for to place the broken twig faultlessly across the beast's back.

The mountain hare, also known as the Alpine or blue hare is a creature of high and desolate mountainous regions. Whilst its summer coat is yellowish brown it changes to a bluish grey as autumn passes, finally turning completely white in time for the prolonged snows of winter. Such varying camouflage with the seasons of the year assists the hare's survival against its chief enemies, the fox, golden eagle, and man.

PLATE XXXVI

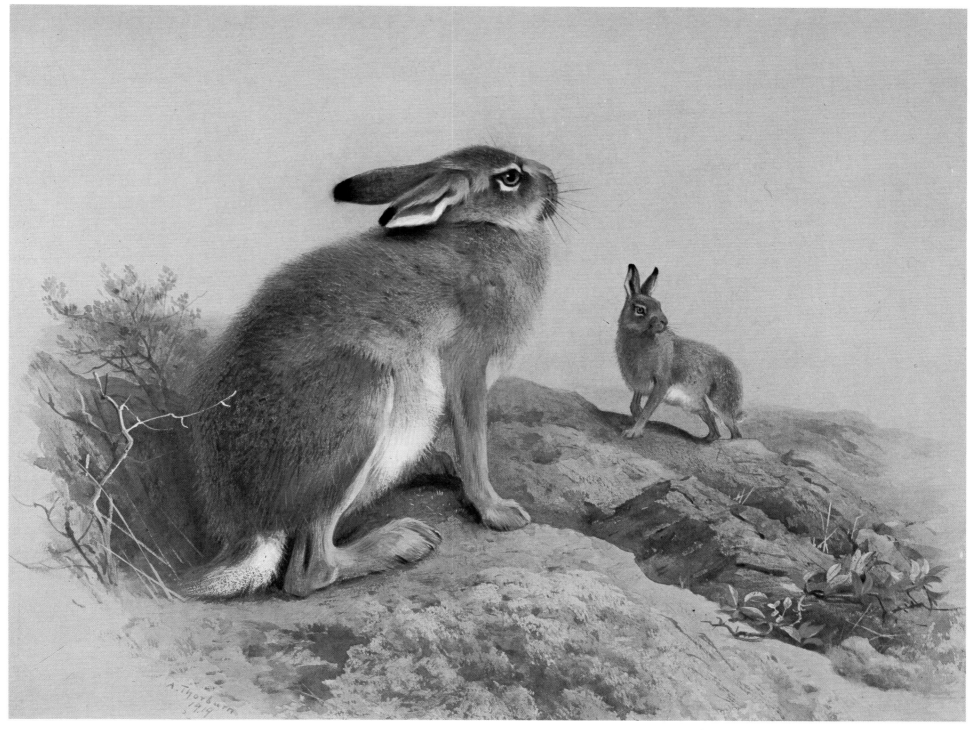

Sunshine and Snow

Wigeon and Teal in Winter
Watercolour 11″ × 15″ 1919

The icy grip of winter continues its hold upon the landscape. And whilst the day is bright and sunny, the wildfowl await the thaw with forbearance. Meanwhile, feeding and preening and even dozing must continue and the drake wigeon and the drake teal feel feebly aggressive in the winter sunshine as they keep watch over their respective mates.

Thorburn much enjoyed painting pictures of wildfowl, and wigeon and teal were particular favourites of his. This picture, besides being a fine example of his bird painting, also shows his method of painting calm water, allowing the reflections to run down across the paper unlike the approach of most artists who streak the water from side to side across the page. The sky is a nice example of his control in the laying on of a wash, controlled yet fluent.

Wigeon and teal are to be found in large numbers around our shores and estuaries in winter and are often

seen feeding together. Whilst many of the teal are resident birds and remain with us to nest in the reeds or riverbank of some quiet backwater, as the days lengthen and spring approaches vast numbers of the wigeon, however, fly northwards from whence they came, to breed in northern Europe and Asia, leaving but a relatively small population behind to nest within our islands.

PLATE XXXVII

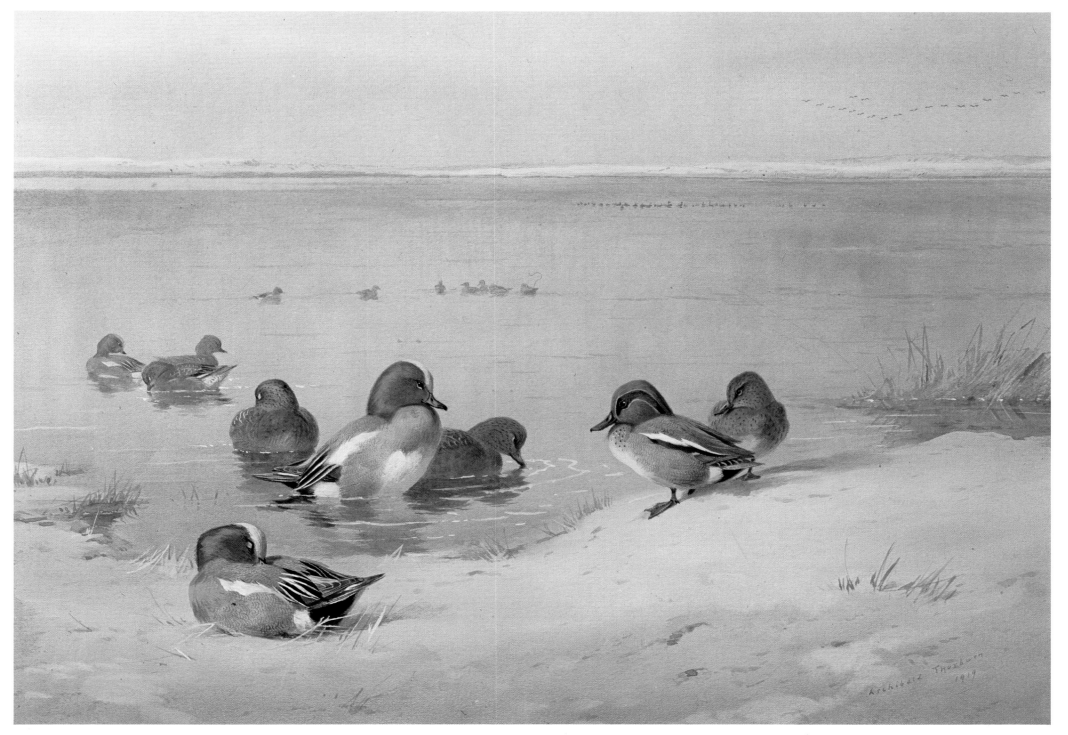

Eiders and Scoters
Watercolour 14″ × 19″ 1921

Bobbing and dipping, rising and falling, a raft of sea ducks rides the swell. As the wind gets up and clouds scurry by, worsening conditions threaten from afar. Gulls swing in ahead of the storm and the little flock of scoters finally rises amid the breakers and makes for calmer waters, not caring to delay a moment longer. Unease spreads to the eiders and, although bred to ride the roughest seas, they prepare to follow the scoters' lead, whilst for the present the mixed party of scoters and velvet scoters chooses to ignore the warning signs and continues sheltering in the calm between the crests of the waves.

A painting full of movement: from the fast-flowing sky to the rising duck and the choppy sea, the scene is convincingly alive and on the move. Painted as an illustration for one of his own books, *Gamebirds and Wildfowl of Great Britain and Ireland*, published in 1923, Thorburn achieves his ambition as outlined in his introduction to the book in which he states: 'My aim in this work has been to represent these birds grouped in their natural surroundings rather than to make scientific plates of the species.'

The eider nests around the coasts of Scotland and some northern parts of England and during the winter does not normally stray far from this breeding area. The common scoter, however, whilst also a resident breeding species in the far north of Scotland, is also a common winter visitor to other parts of Britain, being found all around our coasts. The rather larger and much rarer velvet scoter, a visitor in winter from northern Europe, can sometimes be seen amongst the flocks of common scoters and eiders and is easily recognisable by its very conspicuous white wing patch.

PLATE XXXVIII

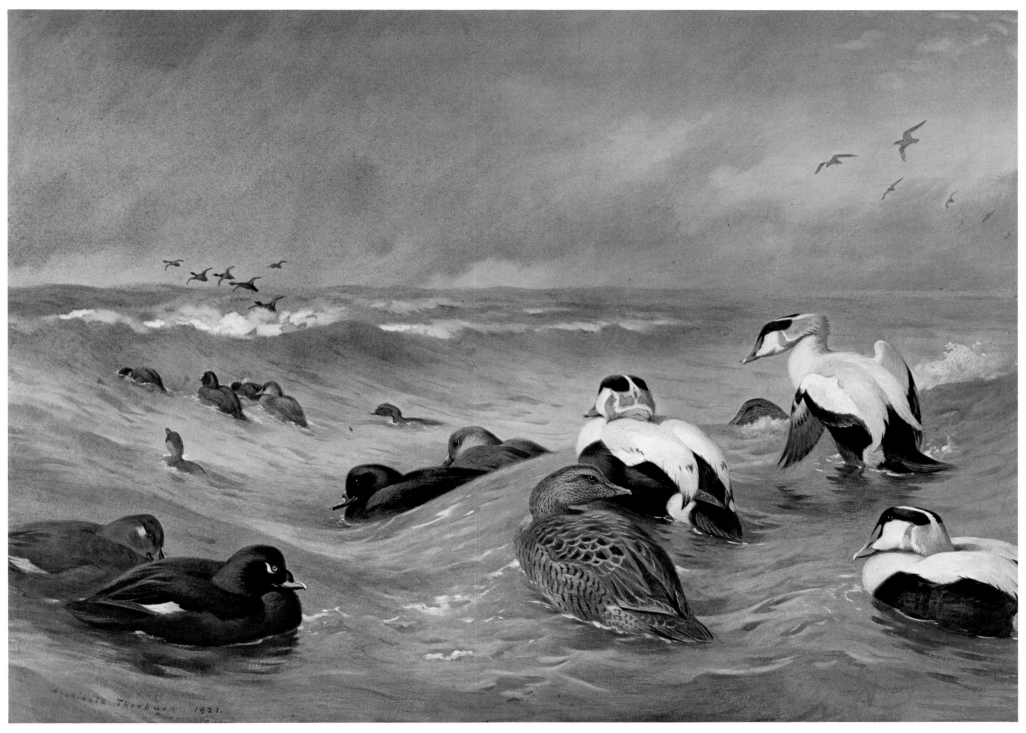

The Eagles' Domain
Watercolour 20¾″ × 29½″ 1921

Tucked in on a ledge high on a remote cliff face the golden eagles have their eyrie. Encamped below the overhanging crag, the nest enjoys a suggestion of shelter from raging storm or blazing sun. With the female bird in attendance, the two eyasses eagerly await the arrival back of the provider of the family, now sailing in over the high tops bringing home a hare for their nourishment.

A very difficult commission for a watercolour artist to undertake, being fundamentally a large brown bird set against a large brown rock, thus greatly reducing the scope for bright and interesting colours and shades. However, the picture is painted with great confidence, free and compelling, light and shade being all important in lifting what could so easily have been a drab and shapeless work. The lovely touches of chestnut on face and wing on the left side of the bird immediately give it shape and form, and Thorburn's abiding attention to nature's detail is expressed in the depiction of a wing of a former victim lying half concealed nearby and by not forgetting to shadow one of the eagle's eyes. The reflections in the tarn bring relief and the glimpse of bright blue sky allows a welcome escape from the confines of the rocks.

Golden eagles nest on remote rock faces in the Highlands of Scotland. The two eggs are laid in March or April and incubated chiefly by the hen, although the cock bird does take a hand. Just over forty days later they hatch and most of the food for the young is caught by the cock bird and carried home to the nest as Thorburn has shown, where normally the hen bird will, after first removing fur or feathers, tear it up into small pieces and feed it to the chicks. Some ten to eleven weeks later the young leave the nest, often remaining with their parents well on into the winter. Sailing and roaming over thousands of acres, either alone or with a partner, they will spend the next few years until in their sixth year they will begin to nest and raise a family of their own.

PLATE XXXIX

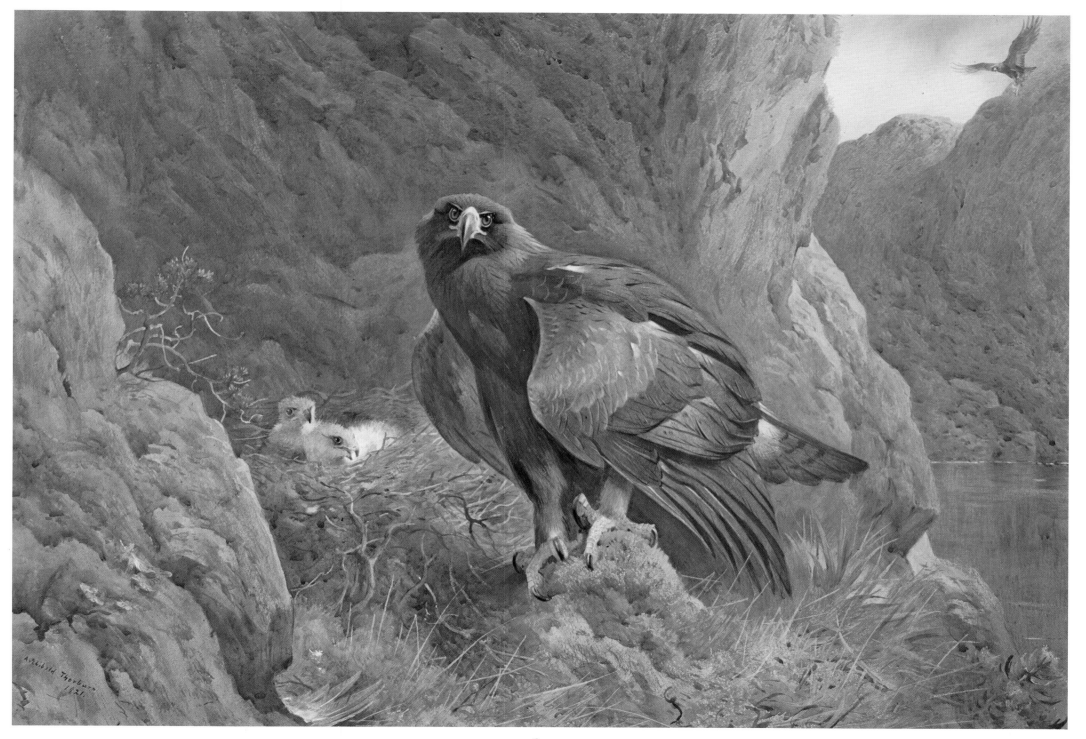

The Grey North Sea
Watercolour $21\frac{1}{2}'' \times 29\frac{3}{4}''$ 1921

On a dank and dark November day, a group of wild-fowl sit out the inclement weather huddled together upon a lonely shore. The pintail and wigeon, waiting for the turn of the tide, doze and preen as best they can. Two oyster catchers pick hopefully along the edge of the shoreline, their plaintive, flutelike piping well nigh engulfed by the thunderous surf and breakers. The feeble winter light tunnels through a break in the overcast sky and casts a ray of hope across the forlorn, sodden expanse of shore.

This picture is another fine example of Thorburn's involvement with the atmosphere of a place and here he captures very well the grim, cold desolation of an east coast stretch of shore on a winter's day, endured but not enjoyed by the flocks of visiting wildfowl. His perpetual attention to the details of nature are shown in the lovely graceful feather, upturned upon the watery sand and the sea shells in the foreground.

Large numbers of pintail and wigeon, along with other wildfowl, visit our coasts and estuaries in the winter months and pintail are particularly graceful and unmistakable birds. Shy and wary, they are difficult to approach usually keeping well away from cover. Whilst they breed sparingly in Britain, their numbers are swelled during the autumn and winter by the arrival of many more of their kinsfolk from more northern climes.

PLATE XL

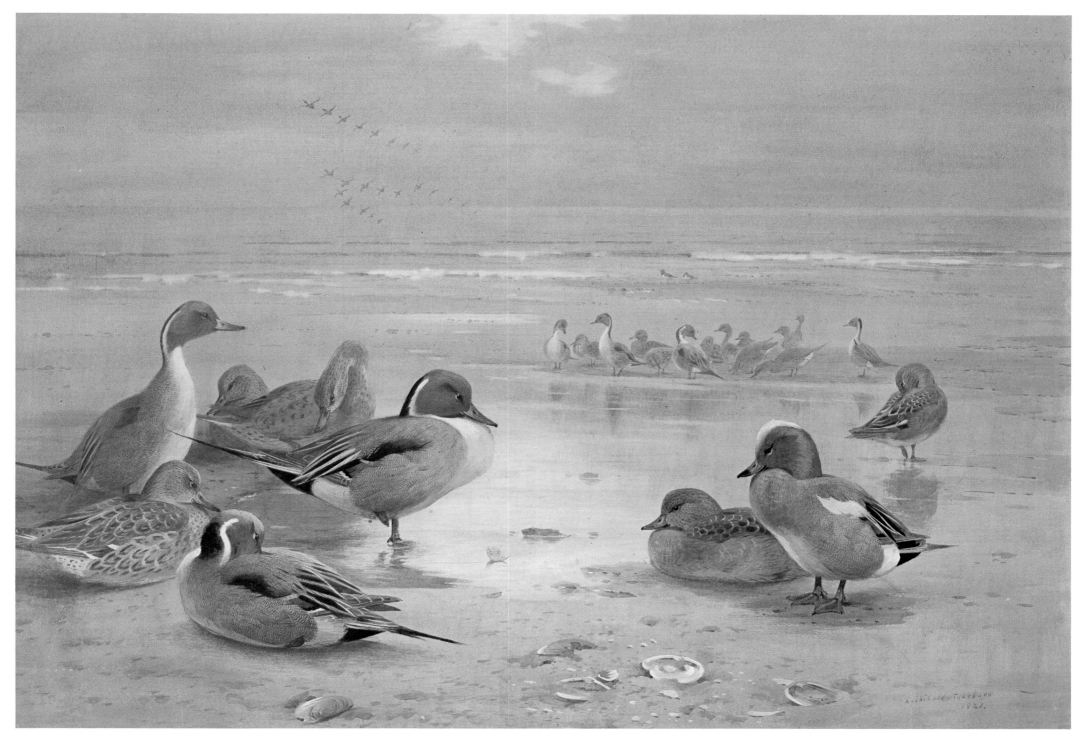

Dormice and Honeysuckle
Watercolour 15″ × 11″ 1921

Silently clinging and swinging through a thicket at the woodland edge, a pair of dormice nimbly pick their way along a summer hedgerow. With jet black eyes alert and noses twitching, the tiny bundles of golden fur dexterously balance and sway on the thinnest frond, ably assisted by their bushy tails and tiny clawed feet. Through prickly briar and twining honeysuckle they thread their way, seeming almost to admire the glorious bloom as they pause momentarily in their excursion.

Painted at the height of Thorburn's career, the picture is an effective and pleasing depiction of these charming creatures. For the most part swiftly painted, expertly generalising the backcloth and emphasising only the animals and the bloom in the foreground, the bold blue wash shows off to perfection the focal point of the main dormouse, the head.

The dormouse is now, alas, a rare sight in Britain where once it was quite widely distributed. With its habitat of shady hazelnut hedgerows and copses retreating before man's ever-increasing devastation of the landscape in his insatiable quest for efficiency, this tiny creature hangs on to life precariously. As winter approaches, the dormouse returns to its nest in thicket or ivy-covered stump to sleep away the cold and cheerless months.

Gleaning after the Shooters
Watercolour 29½″ × 21½″ 1906

Stealthily, almost unmoving through the thicket, the fox edges in on its windfall, wary in the extreme at the sight before its eyes and the scent of blood upon the air. It suspects a trap and can scarcely believe its good fortune in the hard days of winter. The day's shoot over, a pheasant—not destined for the larder—lies stiff upon the woodland snow; one can almost hear the echo of the dull thud with which it hit the ground in an otherwise deserted, silent covert.

Thorburn captures the inertness of the shot pheasant contrasting it well with the intense vitality of the fox inching ever nearer its prize. The snow reflects the sun's rays, highlighting the fading gold of the dead bird's breast feathers, and the few shed feathers and spots of blood upon the snow add a further touch of realism to the scene.

Pheasant shooting begins on 1 October each year and whilst most shot birds are duly retrieved by dog or man, some defy discovery amongst the undergrowth and provide a welcome feast for a hungry fox or other predator.

PLATE XLI

PLATE XLII

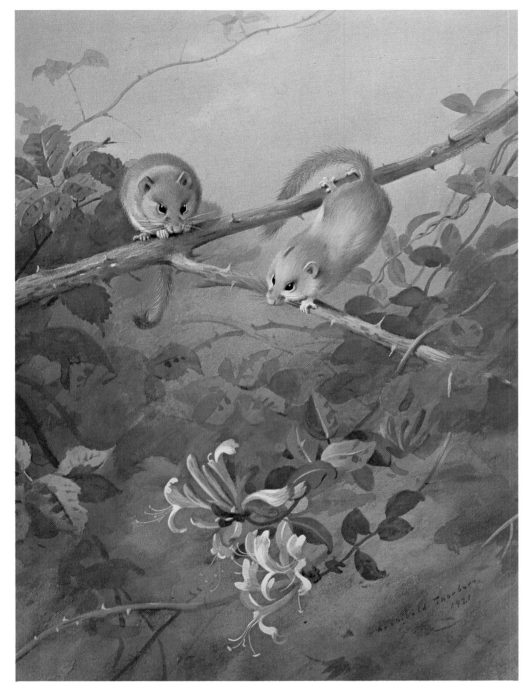

Woodcock Glade
Watercolour 11″ × 14¾″ 1923

Reposing under an autumn sun, a pair of woodcock while away the warm serenity of a woodland glade. Amidst withering bracken and briar they take their ease at the edge of the birch covert, dozing yet alert and comforted by the presence of the fallen tree stump in whose depths one bird hides.

A piece of very fine watercolour painting. Thorburn, now sixty-three, flows on the riot of autumn colour and tint with great speed and freshness, transforming his varying background washes into bracken by the merest stroke of shadow and quickly giving birth to birch trees by limbing them white. As ever, the birds are well finished, picked out clearly from the landscape, yet not over-laboured, remaining very alive and alert.

At the beginning of the century a protracted controversy raged amongst naturalists and sportsmen. Now, however, it is an accepted fact that woodcock will sometimes carry their young between their legs and even occasionally on their backs. Resort to this action is normally brought about by danger, but records exist where young were lifted over obstacles and across water, the parent returning for each chick in turn, and even transporting them to feeding grounds they could not otherwise have reached.

PLATE XLIII

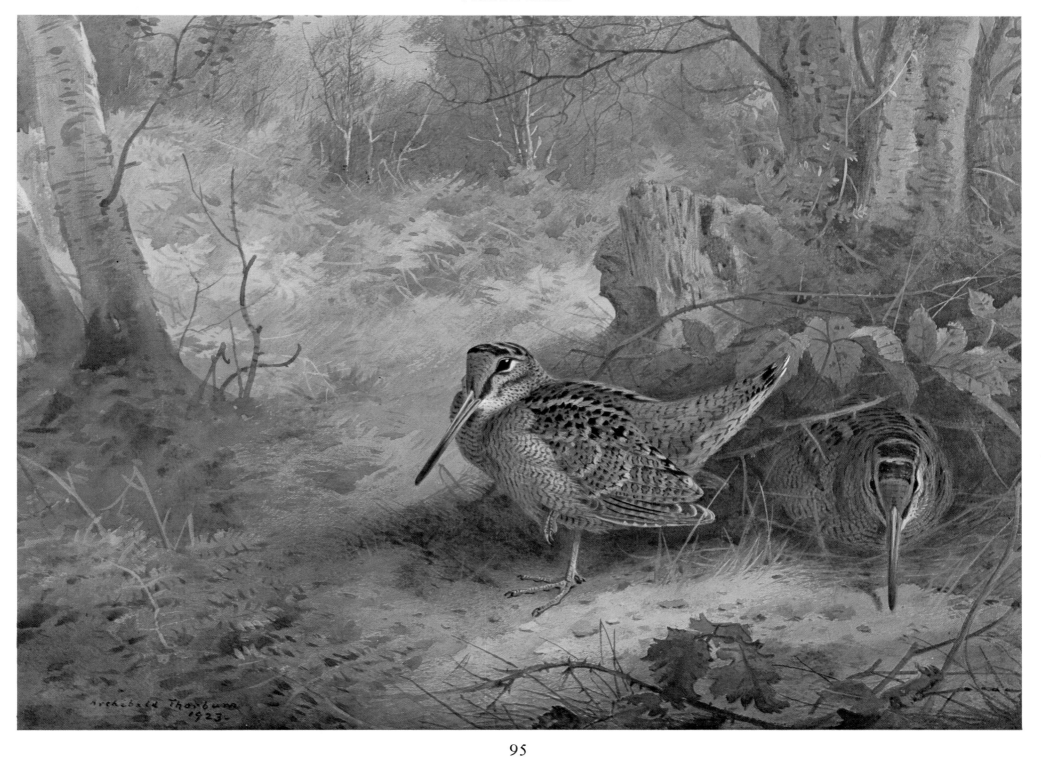

Sunset Glow

Watercolour $21\frac{1}{4}'' \times 29\frac{1}{2}''$ 1921

Through the powdering of snow scattered over the ridge by the icy winds, a covey of ptarmigan drops into the haven of the sheltered corrie, to rejoin companions who are already relishing the warmth of the evening glow. Although the sunset foretells of no further snow, the birds' slumbers in the bitterness of this inhospitable place will be far from pleasurable; so they prepare and preen packing together for comfort, seeking out a hollow here and a shelter there amongst any scant vegetation still uncluttered by the snow.

This was clearly painted by a naturalist as well as an artist. Thorburn knew these birds and this situation intimately from his frequent visits to Gaick Forest and elsewhere, and was greatly impressed by these lovely white creatures and by the effect of setting or rising sun on white birds and snow. He was well aware that although some birds turn completely white in winter many retain a few grey or brown flecked feathers from their autumn plumage to help them harmonize with the rocky landscape.

Ptarmigan pass the winter months in packs which are sometimes very considerable in number with up to several hundred birds being seen together in spells of hard weather. At the first signs of spring, perhaps in late February or early March, these flocks begin to disperse and the cock birds stake out the territories in which they await the arrival of a hen. After pair formation they may still return to a pack each evening, particularly if bad weather returns to the hillsides.

PLATE XLIV

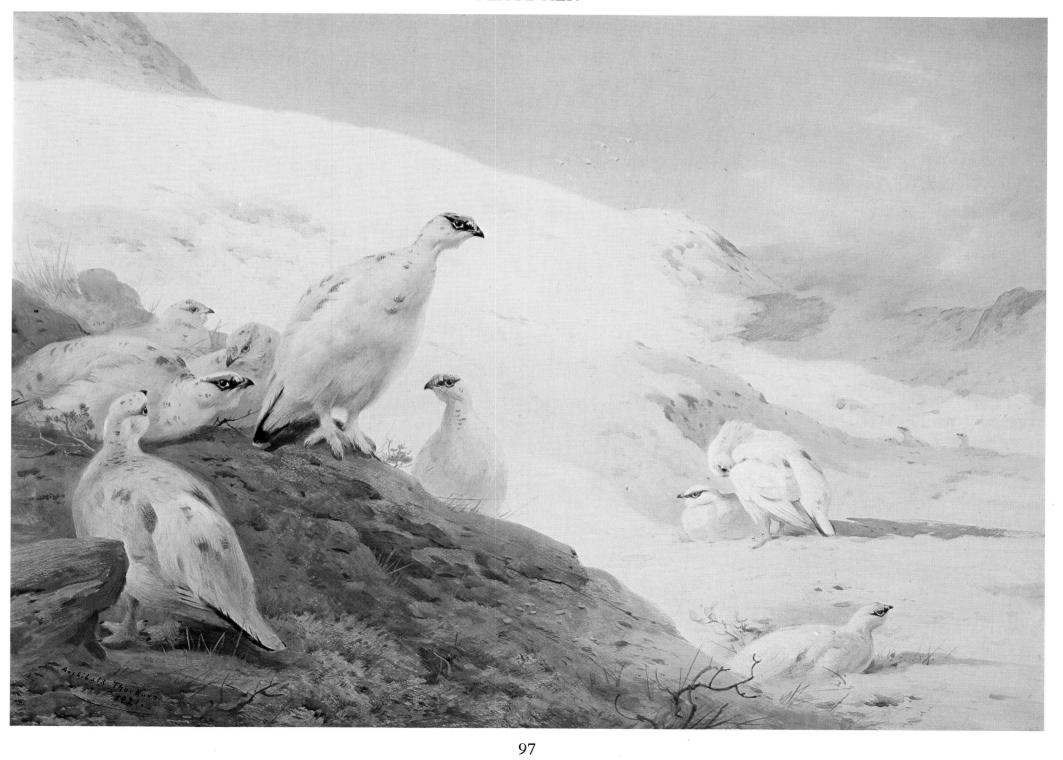

Sparrow-hawk
Watercolour 15″ × 11″ 1923

Well satisfied though still alert, a cock sparrow-hawk rests awhile, digesting the recently captured victim whose feathers drift away from his plucking perch in the cradle of a branch. Pleased with his own efforts, he now watches intently as his mate scours heath and hedgerow for her supper, keen to take her fill before sundown.

Thorburn, the storyteller of natural history painting, here shows us with amazing economy where sparrow-hawks live and the type of terrain they hunt over; and indicates that they feed on small birds and have regular plucking perches on which they prepare their meals.

Thorburn's picture shows off the rich rufous under-parts of the cock sparrow-hawk. The hen bird, though not so brightly attired, being altogether browner above and paler below, is considerably larger than her mate.

Greenland Falcon
Watercolour $14\frac{1}{2}″ × 10\frac{3}{4}″$ 1913

Perched loftily on a bleak and inaccessible promontory, a majestic Greenland falcon surveys the vastness of the arena below. The bird rests languid yet alert, contentedly digesting the mallard, recently struck down on the tarn far below—whose tell-tale feathers lie uneasily nearby before being blown away on the icy wind.

This truly noble bird was greatly admired by Thorburn; he painted a number of studies but none finer than this which he produced for his 1913 Christmas card as well as for a very successful and now much sought after limited edition print, that appeared on the market in 1914. The snow-white plumage and soft dark eye that so appealed to Thorburn belie an enviable turn of speed in flight and of strength at the kill.

Perhaps the most beautiful of the falcons to be seen in Britain the Greenland falcon, considerably larger and heavier than a peregrine falcon, is, alas, a very rare visitor to these islands. It breeds in the remote and well-nigh impenetrable desolation of the mountainous regions of Greenland and Arctic Canada.

PLATE XLV

PLATE XLVI

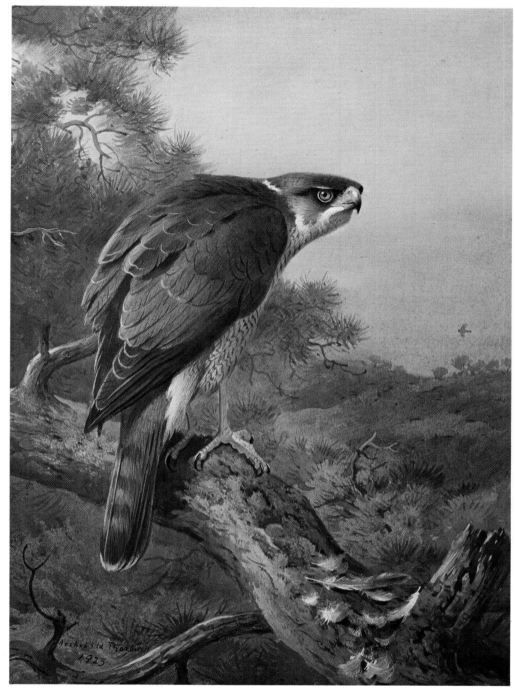

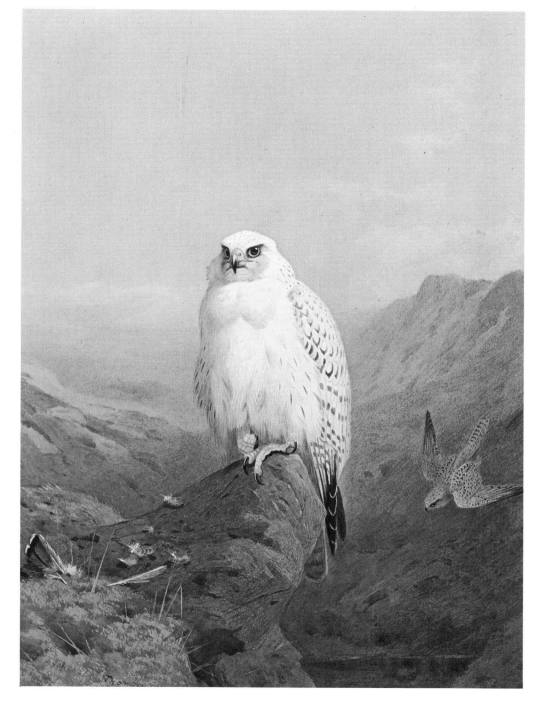

The Shadow of Death
Watercolour $14\frac{3}{4}'' \times 22''$ 1928

High on the wintry slopes in a remote Scottish deer forest, a covey of ptarmigan is endeavouring to cheat death from starvation by foraging for bleak reward beneath the drifted snow. Searching this way and that, behind sheltered stone or frozen ledge, the birds urgently seek out some tasty shoot or berry before the brief day closes. Without warning, a terrifying shadow spreads across the snows and a menacing golden eagle drifts into sight over the ridge and begins scouring this side of the hill for his elusive meal. The ptarmigan crouch immediately and await their fate; many maintaining the uncomfortable poses in which they were caught feeding, seemingly aware of the protection afforded them by their whitened plumage. Alas, the eagle has spotted the covey and although cheating death from starvation, it cannot cheat death from the skies. The great bird drops in upon his prey. The end will be swift; less prolonged and painful than from starvation.

An imaginative piece of painting, undoubtedly born from an incident witnessed by the artist on a visit to the hills. The ptarmigan are drawn in the most difficult though lifelike of positions and postures, yet emerge alive and tense. The shadow of the eagle is produced with crayon and watercolour and the viewer is left to work out which ptarmigan had only seconds to live.

With the onset of winter, ptarmigan lose their speckled grey and brown plumage and take on a white mantle to harmonise with the prolonged winter snows of the high places in which they continue to live. The small coveys of late summer band together to form packs and forage and roost in these vast unvisited solitudes throughout the comfortless months.

PLATE XLVII

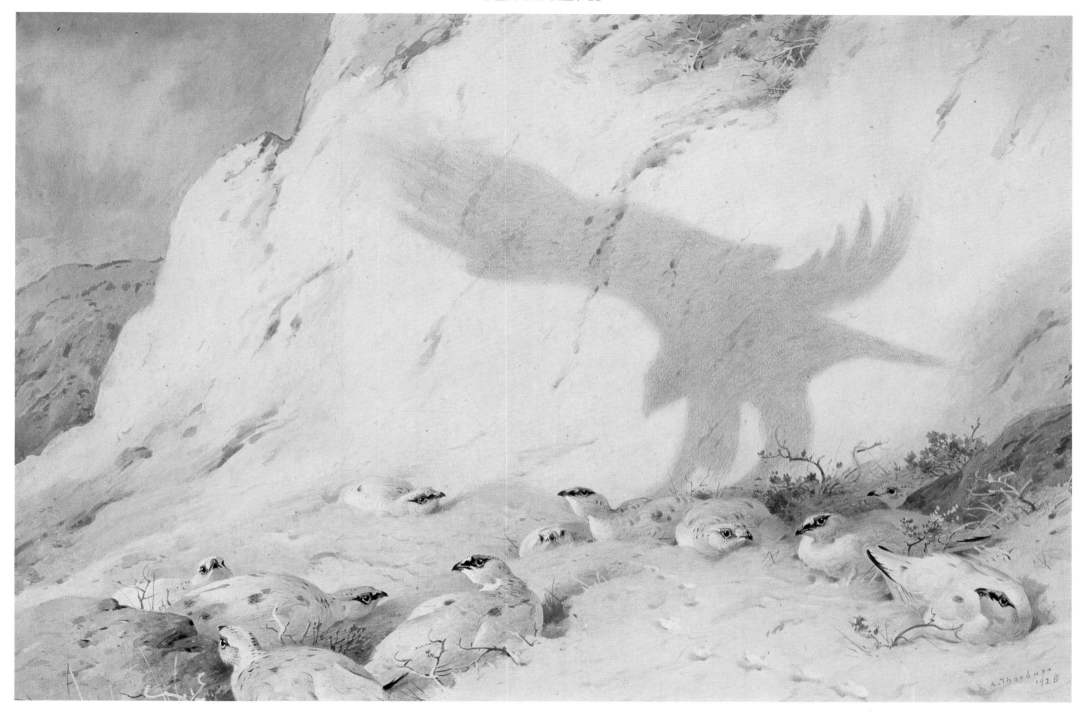

Danger Aloft
Watercolour 21″ × 30″ 1927

High amid the mists clinging to a hillside within the Forest of Gaick in Inverness-shire, a covey of ptarmigan feeds leisurely yet alert. A small herd of red deer have reached a shoulder of the hill in their restless, never-ending quest for food. A single stag has lagged behind, possibly old or sick, and saunters down from the summit to rejoin the others. Suddenly, out of the mists boiling up from the depths of the corrie, a golden eagle appears and the ptarmigan instantly crouch and 'freeze', their autumnal plumage blending to perfection with the boulders and herbage of this high place. They squat, motionless, trusting in their camouflage for survival, waiting for the danger to pass. The deer, also startled by the abrupt apparition of the eagle, stand and stare, mistrusting the huge bird gliding and soaring on outstretched wings above the ridge.

This picture aptly demonstrates Thorburn's supreme craft as a watercolour artist, painted as it was towards the end of his life. Radiating confidence and mastery of control, the landscape was painted wet and flowing, rapidly changing colour and tint in the process. The artist deftly captures fear and alarm on the faces of the deer by two strokes of the brush, cleverly positioning the golden eagle and attracting the eye of the viewer to it by the subtle reddish glow in an otherwise sombre sky, the colour linking well with the red wattles of the ptarmigan and the russet foliage of the blaeberry in the overall composition.

The magnificent vibrant sky has been achieved by the artist's customary practice of laying on the colour and then rubbing off sections of it with a rag, continuing this procedure until the desired effect has been achieved.

Pictures of this size, known as full Imperials, generally took Thorburn a week to complete. Beginning on a Monday he would often finish them by Thursday, though he wrote that occasionally they took him into Friday if proving a little difficult.

Ptarmigan are the grouse of the very high tops and are normally not found below an elevation of two thousand feet. Living in these high, remote, and often inaccessible solitudes, the hill fox and the golden eagle are their chief enemies.

PLATE XLVIII

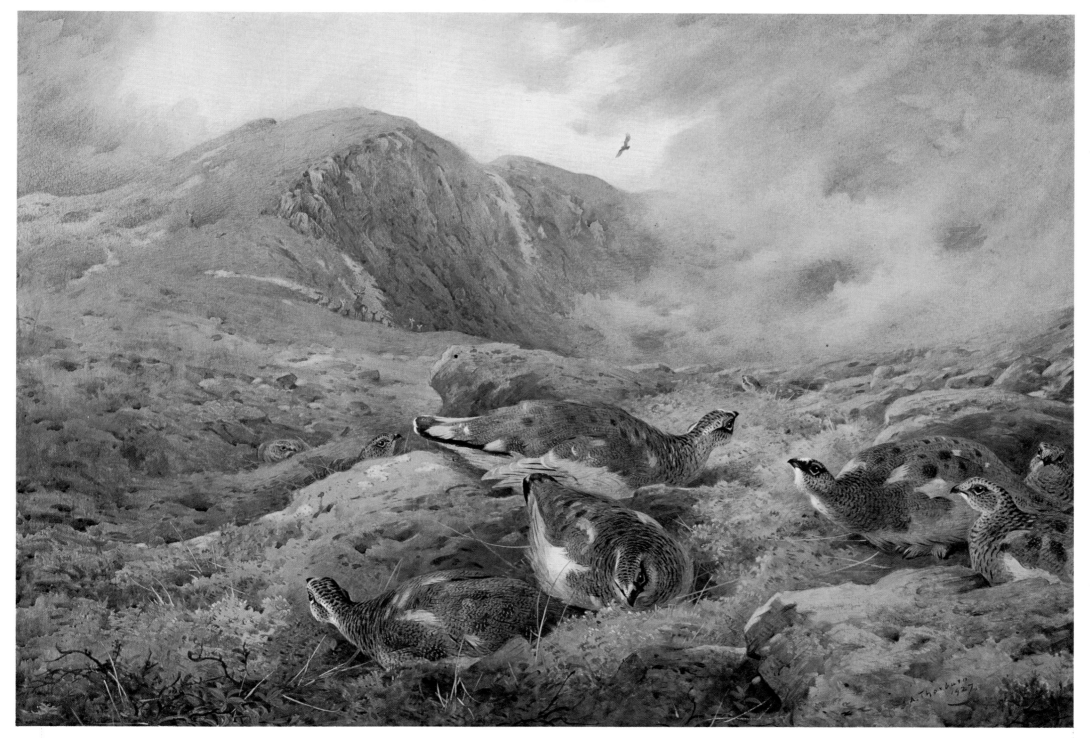

Woodcock and Chicks
Watercolour 11" × 15" 1933

As last year's oak leaves linger on into a new summer, a woodcock broods her chicks under a frond of bracken at the foot of a forest tree. Squatting secretively close to the comfort of the sturdy trunk, she listens intently for any hint of danger amid the stirring branches. Meanwhile, her newly-hatched young, already nimble if the need arises, peep out from within the snugness of her feathers at the shy dog violets and wood anenomes rambling over the woodland floor.

Thorburn painted this charming study of one of his favourite species of bird when he was seventy-three years old. At the time he was suffering considerably from the open wound in his back that he uncomplainingly endured for the last five years of his life, the result of an operation for cancer in 1930. The picture was painted for a limited edition print which his dealer, Embleton of Jermyn Street, London, produced in 1933. His lifelong interest in and love of flowers remains conspicuous as he decks out the foreground with the brightly coloured cluster of blooms.

Woodcock lay their eggs in a slight moss and leaf-lined hollow in the woodland floor, at the foot of a tree or beneath undergrowth. Usually four eggs are laid and these are incubated by the hen bird, taking some three weeks to hatch. Within a few hours the chicks are, if called upon, able to run and crouch amid the woodland cover in their struggle for survival.

PLATE XLIX

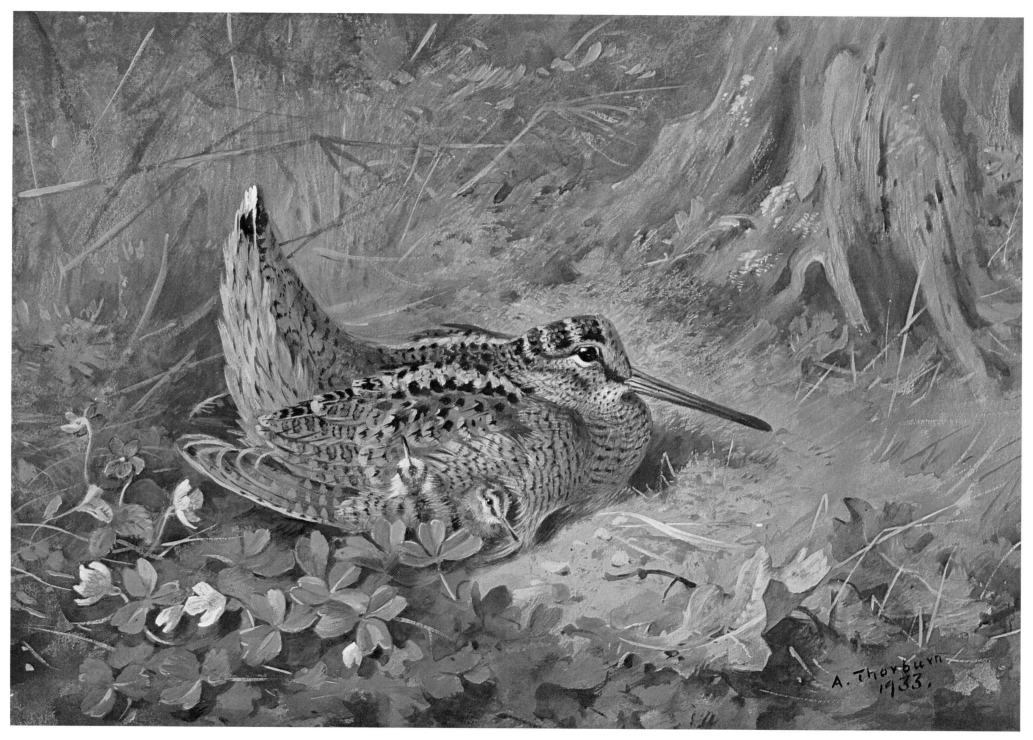

Through the Snowy Coverts
Watercolour $14\frac{3}{4}'' \times 22''$ 1926

Swiftly through the snowy coverts the blackgame thread their way, scarcely disturbing the eerie silence of the winter woodland with their passing as they head homewards under the setting sun. Returning from their moorland feeding grounds to the shelter of the copse, the birds dip through the sun's dying rays strikingly reflected from the snow upon the woodland floor and the bending trees, burdened by the recent blizzard. Gliding through the covert they quickly disappear leaving the place soundless as dusk settles amongst the winterbound trees.

A truly lovely example of Thorburn's depiction of winter. With tinted sky and snow-laden trees and forest floor, he captures the very essence of a lonely woodland in midwinter. His blue rendering of the snow-clad trees against the sunset sky, dramatically sets the temperature of the painting and brings about a realistic chill to the scene. The leading greyhen beautifully picks up the sun's last golden rays deftly reflected from the icy pool beneath her.

Blackgame, unlike pheasants, are not welcomed by foresters due to the damage they unquestionably do to new growth in the younger plantations. Feeding particularly on the young shoots of larch and pine and buds of birch, as well as on various berries and heather shoots, the future looks uncertain for this fine bird, as more and more huge tracts of Scotland are planted out with larch and pine and man encroaches on their natural habitat. They appear to be diminishing annually in many places where they were once plentiful.

PLATE L

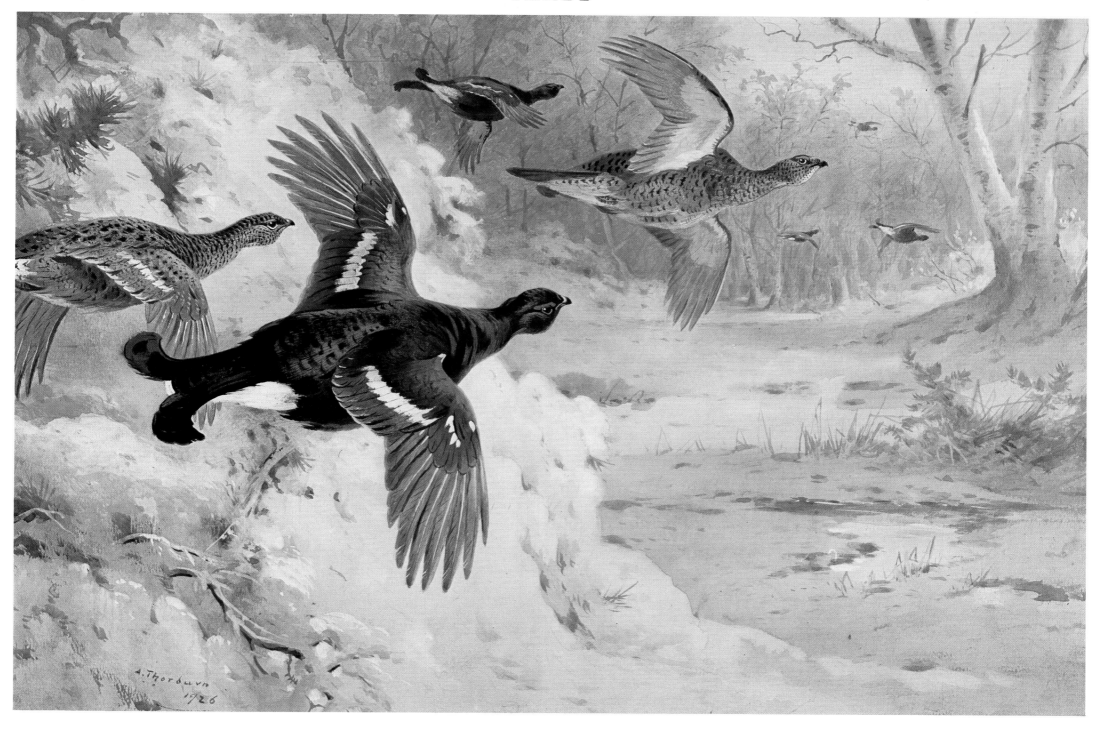

The Old Peat Track
Watercolour $11\frac{1}{2}'' \times 15''$ 1932

Winging in over the rolling, purple-heathered moors, a covey of red grouse skims low and alights on the old peat track for its daily dose of dust bathing and grit. As the clouds scurry rapidly by above, the covey, alertly watched over by two old cock birds, takes grit from the road, the birds preening and dozing in the shelter of the overhanging peat hag, enjoying their noontide relaxation amid the warmth of a waning summer day.

Observing a typical scene on a grouse moor, the artist produced this lovely free work at the age of seventy-two. From it, it is apparent that Thorburn knew and loved such a scene intimately, fully conversant with not only the actions and attitudes of the birds but the tex-

ture and structure of the rocks and the precarious way the peat hags hang as well, their foundations eaten away by the tireless wind and rain.

Following their morning feed, red grouse will regularly visit an earthy, stony track or hillside where they can dust themselves vigorously and take grit, so necessary for survival since it mills the seeds and other foods within their crops.

PLATE LI

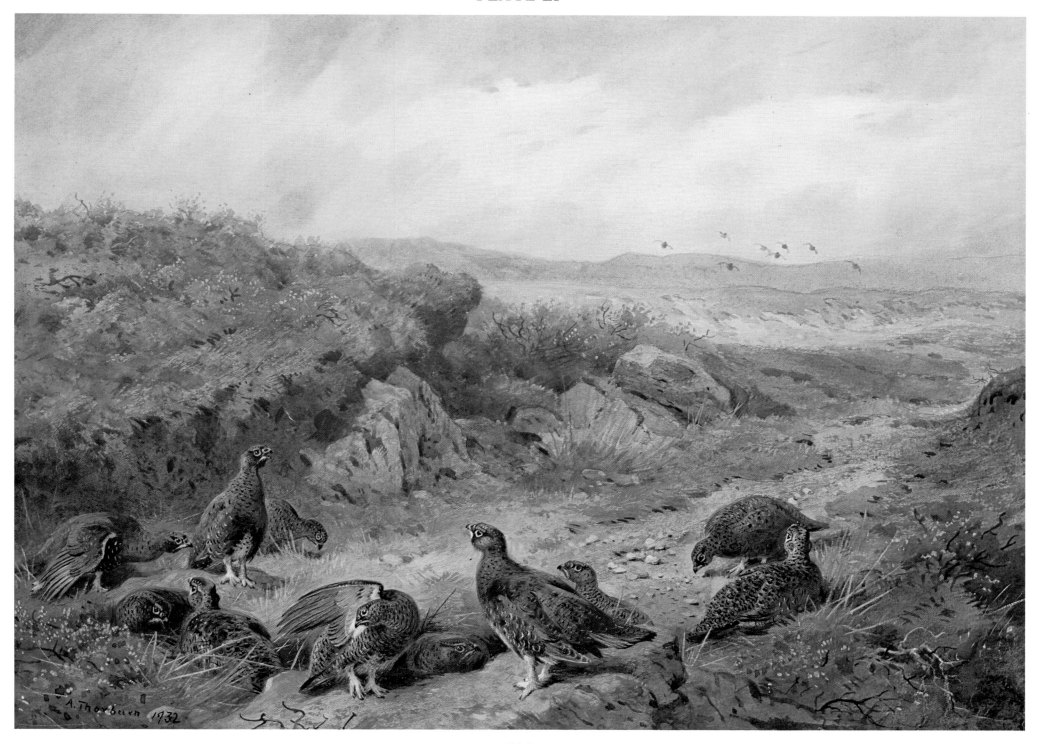

A. Thorburn 1932

In from the North Sea
Watercolour 15" × 22" 1931

With ruffling feathers, two tired woodcock hug the ground, facing into the storm as the north wind lashes in from the sea, scattering the breakers and sand and bowing the bents before it. They rest, wearily, amid the meagre shelter of the dunes close to a withering thistle that has temporarily surrendered to the seasonal adversity of such a place. Once rested and when the storm abates, they will move quickly further inland to more charitable solitudes in which to spend the winter.

Painted at the age of seventy-one and having just endured a major operation for cancer, Thorburn still shows in this work his enduring skill at capturing atmosphere as well as the undercurrent of the ceaseless struggle for survival.

Although a not uncommon resident in Britain, considerable numbers of woodcock from Scandinavia reach our shores in the autumn and spend the winter here. Many arrive on the east coast tired and hungry after their flight, and rest up for a few days before heading inland to some sheltered coppice, close to a suitably moist feeding ground of marsh or boggy woodland glade.

PLATE LII

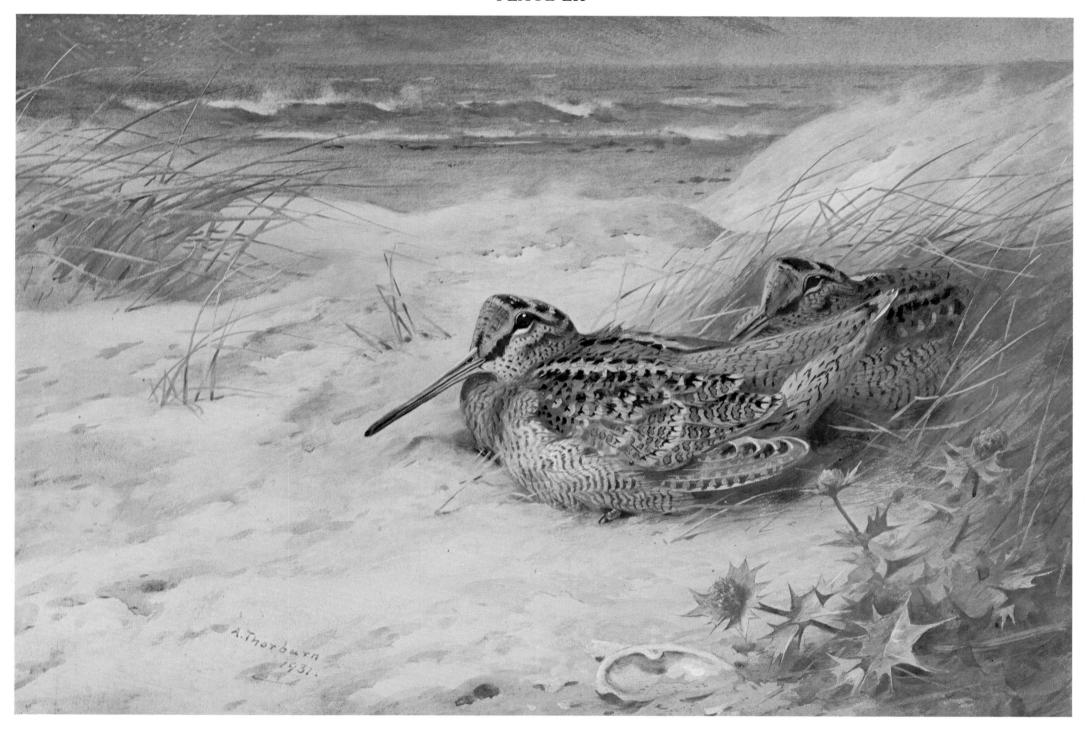

AUTHOR'S NOTE

I first became aware of Thorburn whilst still at school and before my teens had purchased my first original watercolour by him, costing all of one pound, from a second-hand book-shop in Manchester.

In the Art Hall of Manchester Grammar School I spent innumerable and memorable lunch hours sketching and painting wildlife under the expert and helpful eye of another great bird artist, the late C. F. Tunnicliffe RA. Interested in natural history in general and birds in particular almost from the cradle, I still vividly recall hurriedly unwrapping Christmas and birthday presents of bird books and, turning eagerly to the illustrations, contemplating the work of past and present illustrators. Then, as now, only from the brush of Archibald Thorburn did I derive complete enjoyment and satisfaction.

I was a mere four years old when Thorburn died in 1935 and greatly regret never having met and talked to him. I would have loved to watch him flow on the subtle backcloth of moor or glen and place his living creatures within its scenery with such agility, confidence, and compassion. I did, however, meet Thorburn's life-long friend and fellow artist the eminent George Lodge, and frequently took tea with him during the last four years of his very long life (he died in 1954 in his ninety-fourth year). Invariably the conversation would turn to Thorburn and I learnt much about his craft and accomplishments from this kindly old man.

By the time I was eighteen the notion of endeavouring to establish a museum as a permanent memorial to my idol had begun to take shape in my mind and when I moved south and purchased a farm in Cornwall in 1956, I took with me not only the small nucleus of his watercolours that I had assembled but also a determined enthusiasm to turn my boyhood dream into reality at the earliest opportunity. This was achieved when the Thorburn Museum opened in 1973, and today some 150 of his finest works are on permanent exhibition in the museum making available for the first time to the public a sample of this remarkable man's output for all to see and marvel at.

Over the years I have corresponded with admirers of Thorburn's work the world over, received generous help and encouragement from members of the Thorburn family, received invitations to visit and view many private collections, and have been visited by more than 30,000 admirers of Thorburn. In 1977 I had the pleasure and satisfaction of seeing the museum gain awards in National Heritage's 'Museum of the Year' competition as well as in the British Tourist Authority's 'Come to Britain' competition.

In my introductory appreciation I have provided a brief appraisal and account of Thorburn's life and achievements. This is followed by the main section of the book, fifty-two colour plates representing a selection of some of his finest achievements, largely major works never before seen in print or book form, many being huge compelling watercolours originally painted for clients all over Britain. Of the plates all but two are taken from paintings in the museum collection. Each plate is accompanied by a commentary which I have divided into three distinct sections. The first represents my own personal interpretation of the scene. The second contains a few notes on the technicalities of the picture. And the third comprises a sentence or so on the natural history of the creature or creatures in question.

I make no apology for the fact that some two-thirds of the

plates depict gamebirds for pictures of gamebirds and the name of Thorburn have long been synonymous. He was passionately fond of this family of birds and much of his fame can be attributed to the pictures he painted of them. Significantly his very first print was of a pheasant and his last of blackgame.

A sprinkling of book illustration plates have been included to indicate his spectrum and the endmatter include a list of his Royal Academy exhibits, the books he illustrated, and the prints of his work that have appeared on the market during and since his lifetime.

John Southern
5 MAY 1981

ACKNOWLEDGMENTS

Space does not permit me, unfortunately, to mention by name the numerous people who have over the years helped in one way or another to make this book possible but to them all I am most grateful. I must, however, make special mention of Brian Booth of the Tryon & Moorland Gallery for his longstanding co-operation and invaluable help and advice in reading and correcting the text; Anne Harrel for her efficient and untiring liaison between the publishers and myself; Jonathan Martin and the publishers themselves for the care they have taken in ensuring the accuracy of the colour plates; and, in alphabetical order, the Richard Green Gallery, Christine Jackson, Philip Rickman, the late Bill Stenning, Frances and the late Elizabeth Thorburn, and the Tryon Gallery who have all contributed in a special way in the compiling of this book.

Finally my thanks to Barbara, my wife, and to my family who have always supported and encouraged me in my efforts to establish the Thorburn Museum and who have suffered neglect on my part whilst working on this book; and to my secretary, Gwyn, who has uncomplainingly grappled with interpreting my manuscript and has typed it beautifully.

Books illustrated by Archibald Thorburn

ANKER, Jean, *Bird books and bird art an outline of the history and iconography of descriptive ornithology* (Levin and Munksgaard, Copenhagen, 1938, 251 pp.).

ARCHER, Sir Geoffrey Francis and GODMAN, Eva M., *The birds of British Somaliland and the Gulf of Aden* (Gurney and Jackson, London, 1937, 2 vols, 626 pp.), contains Thorburn's last published plates.

BEEBE, C. W. (1918–22), *A Monograph of the pheasants* (Witherby, London, 1918–22, 4 vols, 913 pp.).

BENSON, S. Vere, *The Observer's Book of British Birds* (Warne, London, 1937, 224 pp.).

BLAGDON, F. W., *Shooting. With Game and Gun Room Notes* (1900).

BRANDER, Michael (Ed.), *The International Encyclopedia of Shooting* (Pelham, London, 1972).

BUXTON, Sydney Charles (Earl Buxton), *Fishing and Shooting* (John Murray, London, 1902).

COWARD, T. A., *The birds of the British Isles and their eggs* (Warne, London, 1920–26, 3 vols, c. 1070 pp.).

COWARD, T. A., *Bird haunts and nature memories* (Warne, London, 1922, 214 pp.).

COWARD, T. A., *Bird life at home and abroad with other nature observations* (Warne, London and New York, 1927, 242 pp.).

DALE, Thomas Francis, *The Fox* (Longmans, Green & Co., London, 1906, 'Fur, Feather and Fin' series, no. 12).

DEWAR, George Albermarle Bertie, *Life and Sport in Hampshire* (Longmans, Green & Co., London, 1908).

DRESSER, Henry Eeles, SHARPE, Richard Bowdler and HAY, Arthur Viscount Walden, *A history of the birds in Europe, including all the species inhabiting the western palaearctic region* (London, 9 vols includ. suppl., originally publ. 1871–96 in 93 parts, 5144 pp.).

(DREWITT, C. M.) *Lord Lilford . . . a memoir by his sister* (Hon. Mrs. F. Dawtrey Drewitt). . . . (Smith Elder, London, 1900, 290 pp.).

FISHER, James, *Thorburn's Birds* (Michael Joseph, London, 1967, includes 82 plates from Thorburn, 1915–16).

GLADSTONE, H. S., *Handbook to Lord Lilford's coloured figures of the birds of the British Islands* (Bickers, London, 1917, 69 pp.).

GORDON, Lord Granville, *Sporting Reminiscences* (London, New York, 1902).

GRAHAM, P. A., *Country Pastimes for boys* (1908).

GRIMBLE, Augustus, *The deer forests of Scotland* (Kegan Paul, London, 1896, 324 pp.).

GRIMBLE, Augustus, *Deer-stalking and the deer forests of Scotland* (Kegan Paul, London, 1901, 343 pp.).

GRIMBLE, Augustus, *The salmon rivers of Scotland* (Kegan Paul, London, 1902, 400 pp.).

GRIMBLE, Augustus, *Shooting and salmon fishing and Highland sport* (Kegan Paul, London, 1902, 275 pp.).

GRIMBLE, Augustus, *Highland Sport* (Chapman & Hall, London, 1894).

HARDY (Gathorne-Hardy), Hon. Alfred Erskine, *Autumns in Argyleshire with Rod and Gun* (Longmans, London, 1900).

HARTING, J. E., *Sketches of bird life, from 20 years observation of their haunts and habits* (London, 1883, 292 pp.), contains Thorburn's first published plates.

HARTING, J. E., *The rabbit* (Longmans, 'Fur, Feather and Fin' series, 1898, no. 6; 256 pp.).

HORSFIELD, H. K., *Side Lights on Birds*.

HUDSON, W. H. and BEDDARD, Frank E., *British birds* (Longmans, London, 1895, 363 pp.).

IRBY, Howard L., *The ornithology of the straits of Gibraltar* (Porter, London, 2nd ed., 326 pp.).

KEITH, E. C., *A Countryman's Creed* (1938).

KOENIG, A. (F.), *Avifauna Spitzbergensis . . .* (Author, Bonn, 1911, 294 pp.).

LILFORD, Lord, *Coloured figures of the birds of the British Islands* (Porter, London, 1885–98, 36 parts in 7 vols, 974 pp.).

LILFORD, Lord, *Notes on the birds of Northamptonshire and neighbourhood* (Porter, London, 1895, 2 vols, 706 pp.).

LITTLE, Alicia Bewicke (Mrs Archibald), *Our pet herons* (Roy. Soc. Protect. Birds Leafl. no. 35, 1900, 4 p.).

MACKIE, Sir P., *The Keepers Book* (1928).

MACPHERSON, H. A. and others, *The Partridge* (Longmans, London, 1894, 'Fur, Feather and Fin' series, no. 1; 276 pp.).

MACPHERSON, H. A. and others, *The Grouse* (Ibid., 1894, no. 2; 293 pp.).

MACPHERSON, H. A. and others, *The Pheasant* (Ibid., 1894, no. 3; 265 pp.).

MACPHERSON, H. A. and others, *The Hare* (Ibid., 1896, no. 4; 263 pp.).

MACPHERSON, H. A. and others, *The red deer* (Ibid., 1896, no. 5; 328 pp.).

MATHEW, M. A., *The Birds of Pembrokeshire and its Islands* (1894).

MATSCHIE, Paul, *Bilder aus dem Tierleben* (Union, Stuttgart, 1900, 476 pp.).

MEINERTZHAGEN, R., *Nicholl's Birds of Egypt* (1930).

MILLAIS, J. G., *The natural history of the British surface-feeding ducks* (Longmans, London, 1902, 168 pp.).

MILLAIS, J. G., *The Mammals of Great Britain and Ireland* (Longmans, London, 1904-6, 3 vols, 1048 pp.).

MILLAIS, J. G., *The natural history of the British game birds* (Longmans, London, 1909, 142 pp.).

MILLAIS, J. G., *British diving ducks* (Longmans, London, 1913, 2 vols, 305 pp.).

MILLAIS, J. G., *Rhododendrons . . . and the various hybrids* (Longmans, London, 1917, 1924, 2 vols, 532 pp.).

MILLAIS, J. G. and others, *British gamebirds and wildfowl* (The Gun at Home and Abroad, London, 2 vols, 455 pp.).

OWEN, J. A., *The Lilford vivaria* (Pall Mall Mag., 1896 Sept., 48-61).

OWEN, J. A. (Ed.), *Drift from Long Shore* (1898).

PEEK, Hedley, *The Poetry of Sport* (Longmans, London, 1885, Badminton Library).

PYCRAFT, W. P., *Birds of Great Britain and their natural history* (Williams and Norgate, London, 1934, 206 pp.).

SHAW, L. H. de Visme and others, *Snipe and woodcock* (Longmans, London, 1908, 'Fur, Feather and Fin' series, no. 10; 298 pp.).

SITWELL, Sacheverell, BUCHANAN, Handasyde and FISHER, James, *Fine bird books 1700-1900* (Collins and van Nostrand, London and New York, 1953, 120 pp.).

STEWART, Henry Elliott, *The Birds of Our Country* (Digby & Long, London, 1897).

SUFFOLK (Earl of), and others (Ed.), *The Encyclopaedia of Sport* (1897-98, 2 vols).

SWAYSLAND, Walter, *Familiar wild birds* (Cassell, London, 1883-88, 4 vols, 640 pp.), 144 coloured lithographs by Thorburn; his first major publishing assignment. Contains Thorburn's first coloured plates.

THORBURN, Archibald, *British birds* (London, 1915-16 and 1918, 420 pp.).

THORBURN, Archibald, *A naturalist's sketch book* (Longmans, London, 1919, 72 pp.).

THORBURN, Archibald, *British mammals* (Longmans, London, 1920-21, 2 vols, 108 pp.).

THORBURN, Archibald, *Game birds and wild-fowl of Great Britain and Ireland* (Longmans, London, 1923, 80 pp.).

THORBURN, Archibald, *British birds* (Longmans, London, 1925-26, 4 vols, 638 pp.).

(TREVOR-BATTYE, Aubyn) (1897). 'Archibald Thorburn and his work.' *The Artist* (Lond) 20 (211): 318-30.

TREVOR-BATTYE, Aubyn (Ed.), *Lord Lilford on birds . . .* (Hutchinson, London, 1903, 312 pp.).

WATSON, A. E. T., *King Edward VII as a Sportsman* (1911).

Colour prints and proofs of Thorburn's work published from 1900–1980

Unfortunately no catalogue or official list exists of all the titles, dates, and sizes of the editions published. The following list is as complete as is possible from the records available though omissions may well have been made.

Pheasant (1st Christmas Card)
Blackcock (2nd Christmas Card)

1900 *Partridges in stubble.* Leggatt Bros.
1901 *Partridges and Goldfinch.* Baird Carter.
1902 *Grouse calling.* Baird Carter.
1903 *Woodcock and Robin.* Baird Carter.
Capercaillie in Scots Pine. Baird Carter.
Grey and French Partridge. Baird Carter.
Wigeon and Teal. Baird Carter.
Ptarmigan on the Tops. Baird Carter.
Blackcock in Flight. Baird Carter.
Woodpigeons in Beech Tree. Baird Carter.
Grouse over the Moor. 'The Twelfth.' Baird Carter.
Pheasants in the Snow. Baird Carter.
Woodcock and Oystercatcher – 'The First Arrival.' Baird Carter.
Mallard in Winter. Baird Carter.
Golden Plover. Baird Carter.
1904 *Pheasants in Winter – Birchwoods.* Baird Carter.
1905 *Lapwing and Golden Plover.* Baird Carter.
1906 *Pintail, Wigeon and Teal.* Baird Carter.
1907 *Golden Eagle on Rocky Outcrop.* Baird Carter.
Pheasants – 'Frost in the Coverts.' Baird Carter.
Partridges – 'The Close of a Winter's Day.' Baird Carter.

Set of six Red Deer of Scotland. Baird Carter.
Shadowed.
The Peat Hag.
Disputed Rights.
Changing Quarters.
After the Mist has Lifted.
The First Snow on the Tops.
1908 *Peregrine on Drake Teal.* Baird Carter.
1909 *Grouse – 'The Sentinel.'* No publisher.
Ptarmigan in the Snow. Baird Carter.
1910 *Snipe in the Reeds.* Baird Carter.
1911 *Blackcock at the Lek.* Baird Carter.
1912 *Mallard on the Lake at Sandringham.* Baird Carter.
1913 *Greenland Falcon.* Baird Carter.
1914 *Woodpigeons on Beechmast.* Baird Carter.
1915 *Cock and Hen Bullfinch.* Baird Carter.
1916 *Goldfinches on Thistle.* Baird Carter.
1917 *Wigeon and Teal.* Baird Carter.
1918 *Fox and dead Pheasant – 'The Windfall.'* Baird Carter.
1919 *Golden-eye and Tufted Duck.*
Set of twelve Birds of Prey. Limited 150 sets. Baird Carter/Embleton.
Marsh Harrier.
Golden Eagle.
Sparrow Hawk.
Honey Buzzard.
Peregrine.
Merlin.
Montagu's Harrier.
Goshawk.
Red Kite.

Iceland Gyr Falcon.
Hobby.
Kestrel.
1920 *Oystercatchers, Terns and Ringed Plover.* Baird Carter/Embleton.
1921 *Kingfisher – 'Frozen-out Fisherman.'* Embleton.
Grouse coming over the Burn. Embleton.
Winter Blackbird. Embleton.
Pheasants. Embleton.
Jay. Embleton.
1922 *Wigeon over the Estuary.* Embleton.
Pintail on the Shore. Embleton.
Mallard on the Shore. Embleton.
Bluetits on Teasel. Embleton.
1923 *Snipe probing.* Embleton.
Woodcock. Embleton.
Cock and hen Redstart. Embleton.
Golden Eagles at the Eyrie. Embleton.
Woodcock and Chicks. Embleton.
1924 *Robin and Wren.* Embleton.
1925 *Blackcock through the Silver Birches.* Embleton.
Pheasants through the Oak Wood. Embleton.
Partridges – 'September Morning.' Embleton.
1926 *Shoveller by the Mere.* Embleton.
1927 *Grouse over the Moor.* Embleton.
Partridges and young. Embleton.
Mallard in Squally Weather. Embleton.
Wigeon alighting. Embleton.
Grouse sheltering. Embleton.
1928 *Partridges in the Stubble.* Embleton.

Nuthatch. Embleton.

Summer Kingfisher. Embleton.

Ptarmigan – 'Sunshine and Drift.'
Embleton.

1929 *House Martins.* Embleton.

1930 *Great Tits and Mistletoe.* Embleton.

1931 *Pheasants – 'The Old and the New.'*
Embleton.

1932 *Grouse in the peat hags.* Embleton.

1933 *Woodcock and dog violets.* Embleton.

1934 *Blackcock on silver birches.* Embleton.

1974 *Red Squirrels.* Edition of 250. Tryon
Gallery Ltd.

1975 *Longtailed Tits.* Edition of 500. Tryon
Gallery Ltd.

Woodcock. Edition of 500. Tryon
Gallery Ltd.

Amid the Highlands – Set of six.
Edition of 500. Tryon Gallery Ltd.
 Red Deer – 'Voices of the Forest.'
 Roe Deer – 'Overlooked.'
 Ptarmigan – 'Danger Aloft.'
 Red Grouse – 'At the Break of Day.''
 *Blackgame – 'The Glen among the
 Moors.'*
 Golden Eagle – 'The Eagle's Eyrie.'

1978 *Pheasants – 'The First Touch of Winter.'*
Edition of 500. Tryon Gallery Ltd.

Partridge – 'September Siesta.' Edition of
500. Tryon Gallery Ltd.

The following two sets of prints were pub-
lished by Longmans, Green & Co. No date
known – possibly 1912. 18″ × 14″.

British Mammals

1. The Mole.
2. Wood Mouse, Harvest Mouse, Dormouse.
3. Water Vole, Lesser Shrew, Common
 Shrew.
4. The Otter.
5. The Hedgehog.
6. The Red Deer.
7. The Badger.
8. The Fox.
9. The Wild Cat.
10. The Grey Seal.
11. Polecat, Weasel.
12. Mountain Hare, Common Hare.

Flowers, Butterflies and Moths

1. April – Primrose, Blue Bell, Small White
 Wood Argus.
2. May – Cuckoo Flower, Marsh Marigold,
 Wall Butterfly, Orange Tip.
3. June – Meadow Sweet, Red Campion,
 Pearl-bordered Fritillary, Chalk-hill Blue.
4. June – Common Poppy, Blue Bottle,
 Meadow Brown, Common Blue.
5. July – Foxglove, Chervil, Marbled White
 Butterfly, Burnet Moth.
6. July – Honeysuckle, Dog Rose, Silver-
 washed Fritillary, Large Heath.
7. August – Common Mallow, Ox-eye
 Daisy, Brimstone, Small Tortoiseshell.
8. August – Ragwort, Harebell, Peacock
 Butterfly, Hummingbird Moth.
9. September – Purple Loosestrife, Water
 Mint, Red Admiral, Small Copper.
10. September – Spear Thistle, Cross-leaved
 Heath, Painted Lady Butterfly, Yellow
 Underwing.

Pictures exhibited at the Royal Academy by Archibald Thorburn

Date	Exhibition Number	Title
		THORBURN, Archibald . . . Painter.
		– Forest Field, Kelso.
1880	714	On the Moor
	824	The Victim
1881	751	A Christmas Hamper
1882	959	Blackgame
	972	The Twelfth of August
	981	The First of October
1883	999	The Golden Eagle
		– 17 Cumberland Walk, Tunbridge Wells.
1885	1328	Undisturbed
		– 25 Stanley Gardens, N.W.
1887	1213	The Eagle's Crag
1888	1249	The Covey at Daybreak
	1324	Blackgame Disturbed
1890	1327	The Pack at Sunrise
		– 88 Fellowes Road.
1892	921	The Last Drive
	1203	Eagles disturbed in their Nest
1893	549	A Grouse Drive
	977	Golden Eagles on the Watch
1894	1079	The Lost Hind
1895	920	The Watchful Hinds
1898	1054	The Home of the Golden Eagle
1899	1128	The Lost Stag
1900	1195	The Eagle's Stronghold

List of R.S.P.B. Christmas Cards painted by Thorburn and donated by him to the Society

1899 Roseate Terns. (Accompanied by a verse by the Poet Laureate)

1905 Blackbird.

1916 Whitethroat.

1917 Robin. *Behind the Lines.*

1918 Skylark. *No-man's Land.*

1919 Ringed Plover. *First Impressions.*

1923 Goldfinch. *King Harry.*

1924 Bullfinch (on blackthorn). *John Bull.*

1925 Greater Spotted Woodpecker. *The Forester's Friend.*

1926 Redstart. *The Fire-tail.*

1927 Grey Wagtail.

1928 Nuthatch. *Britain's Blue-bird.*

1929 Sandpiper by water.

1930 Wheatear. *The Herald of Spring.*

1931 Oystercatchers. *Sea-Piets.*

1932 Stonechat on bracken stem.

1933 Chaffinch. *The Bachelor's Finch.* (Original presented to King George V)

1934 Longtailed Tits.

1935 Goldcrest.

Right *Thorburn's 1925 Christmas card for the R.S.P.B.*

would be left out.

2nd Meta carpal
1st Phalanx
Scaphoid
2nd Phalanx
Bastard Wing
(alula or ala spuria)
1st Digit
1st Metacarpal

Humerus

Radius

ulna

cuneiform

3rd Metacarpal

Pennae humerales

humerals (tectrices)

1st Phalanx
2nd Phalanx
3rd Phalanx

REMICLE

2nd Digit

9

8

7

(7) I (8) I (9) II (10) I

Addigital Middigitals Predig.

Metacarpals

Digitals

CUBITALS or SECONDARIES

METACARPO-DIGITALS
or PRIMARIES.

WILD DUCK (Anas boschas)